CHICANO VISIONS

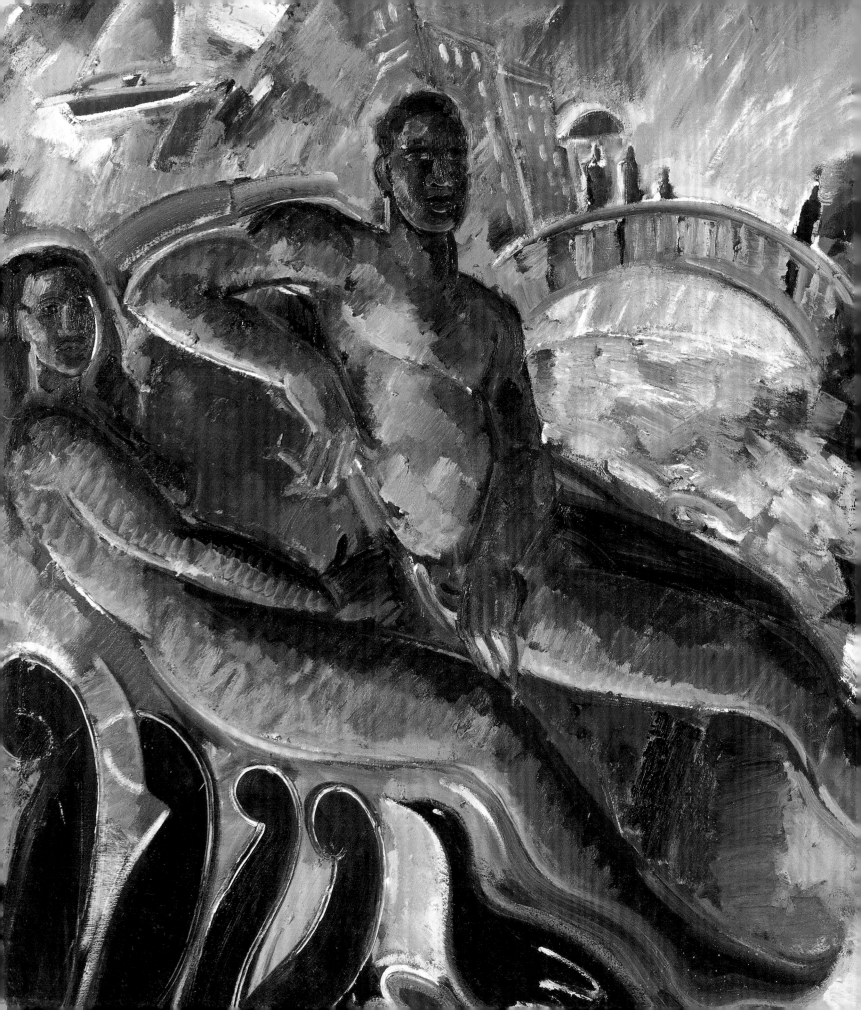

CHICANO VISIONS
AMERICAN PAINTERS ON THE VERGE

CHEECH MARIN

ESSAYS BY MAX BENAVIDEZ, CONSTANCE CORTEZ, TERE ROMO

A BULFINCH PRESS BOOK
LITTLE, BROWN AND COMPANY
BOSTON NEW YORK LONDON

First published on the occasion of the exhibition "Chicano Vis

Page 1: Wayne Alaniz Healy. *Beautiful Downtown Boyle Heights*
Pages 2–3: Carlos Almaraz. *California Natives,* detail
Page 5: Rupert García. *Homenaje A Tania y The Soviet Defeat,* de

First North American Edition

ISBN 0-8212-2805-6 (hardcover edition)
ISBN 0-8212-2806-4 (paperback edition)

Library of Congress Control Number 2002104645

A Bespoke Book
Design: Ana Rogers

Bulfinch Press is an imprint and trademark of Little, Brown ai

Printed in Singapore

As many of our illustrated books have had pages removed, or pictures cut out we are now monitoring such books. Please fill in the following to indicate that this book was still complete when you returned it

Name	Signature	Date Returned	Checked By
ALLEN	All	ALL PAGES CORRECT	21/12/09.
all pages intact		14/10/16	

CONTENTS

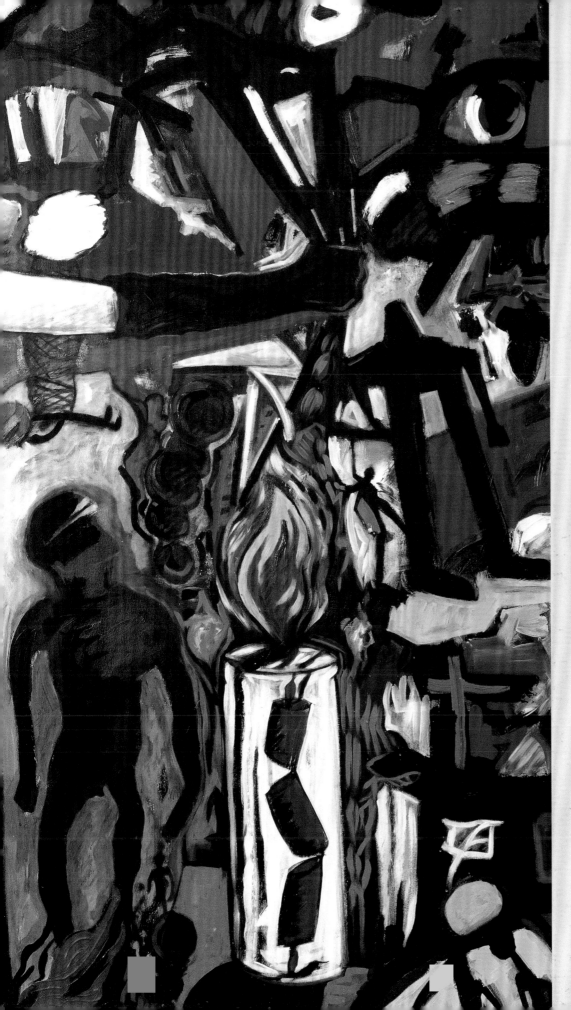

INTRODUCTION

THE CHICANO SCHOOL OF PAINTING

The first time I stood in front of a Chicano painting—it was George Yepes's *Amor amatizado*—I had the same feeling as when I first heard a tune by the Beatles. It was a sense of experiencing something very familiar and very *new*. The Beatles had built their music on the backs of their rock 'n roll heroes, but their interpretation was fresh and distinctive. As the Beatles started writing their own songs, their own roots were clearly evident, and yet they were moving beyond the influences around them to create a whole new musical landscape. The same can be said about my appreciation of Chicano painters: The more art I looked at and thought about, the more that initial feeling of something new and "known" was reinforced, and with it a recognition of something powerful at work.

Having been self-educated in art from an early age (I was probably in the fifth or sixth grade), I recognized the various models from which the Chicano artists drew inspiration: Impressionism, Expressionism, the Mexican Mural Movement, Photorealism, *Retablo* painting, are all examples. But the common link of course was the central "influence" common to all the artists—they were Chicanos and looked at the world through Chicano eyes. Over time, this so-called common link begat something broader and more important. A much larger picture was emerging, and that picture was a new school of art in formation.

Gronk. *La Tormenta Returns.* **1999 (detail)**

If a school can be defined as a place where people can come to learn, exchange ideas, have multiple views and different approaches to the same subject, and influence each other as they agree and disagree, then a Chicano School of Painting more than qualifies for such a definition. What distinguishes this body of work is of course not simply that it has no interest in rehashing the familiar landmarks of Impressionism, say, or abstraction or pattern & decoration. Nor is this art whose mandate is a reaction against other stylistic precedents in the history of art. Rather, it is a visual interpretation of a shared culture that unfolds in one distinctive painting after another.

The art movement developed outside of the national or international spotlight, and in separate locations, notably Los Angeles and San Antonio. In its earliest days, three decades ago, this was a movement that developed organically, with little communication among the artists. What bound them together was the DNA of common shared experience. Yes, there were a few important groups (Con Safo, Royal Chicano Air Force, Los Four, and Asco), but in general many of the artists shown in these pages never even met before their work was collected in the exhibition "Chicano Visions: American Painters on the Verge." With little commercial encouragement, these artists have struggled to gain acceptance in the gallery world. Many painters show their works in restaurants, coffeehouses, or wherever there is a wall and an audience. What matters is that they continue to create.

Overwhelmingly university or art-school trained, these artists were exposed to art history and major contemporary world art trends in addition to the constant and surrounding influence of Mexican art and culture. Indeed, it is this blending of influences—traditional Mexican and American Pop— that defines the school. Simultaneously naïve and sophisticated, the art mirrors the artists' own experience of a bicultural environment. Chicanos "code switch" amongst themselves all the time: they go back and forth almost at random between languages and cultures both spoken and visual. Code switching allows for total immersion, the creation of a whole greater than the sum of its parts.

Going into its fourth generation of artists, the school continues to grow without losing its essential characteristic—the visual interpretation of the Chicano experience. Whatever the means—historical, political, spiritual, emotional, humorous—these painters each find a unique way to express their singular point of view. And just as Chicanos have been influenced by their predecessors, so now they exert an influence on American pop culture. From hip-hop dress to the predominance of salsa as the number one condiment—over ketchup!—the Latin experience is not just recognized as something "interesting," a "colorful sidelight," but as one of the main threads that makes up America's cultural fabric.

In the end, however, it is the lone art lover standing in front of a great painting with his jaw dropped, transported to a place both timeless and immediate, that provides the ultimate validation for this new movement in art. For more than twenty years, Chicano painters have done that for me. I pass along this world with love and affection, *y con amor, carino y besos.*

—Cheech Marin
San Francisco, 2002

Frank Romero. *The Arrest of the Paleteros*. 1996 (detail)

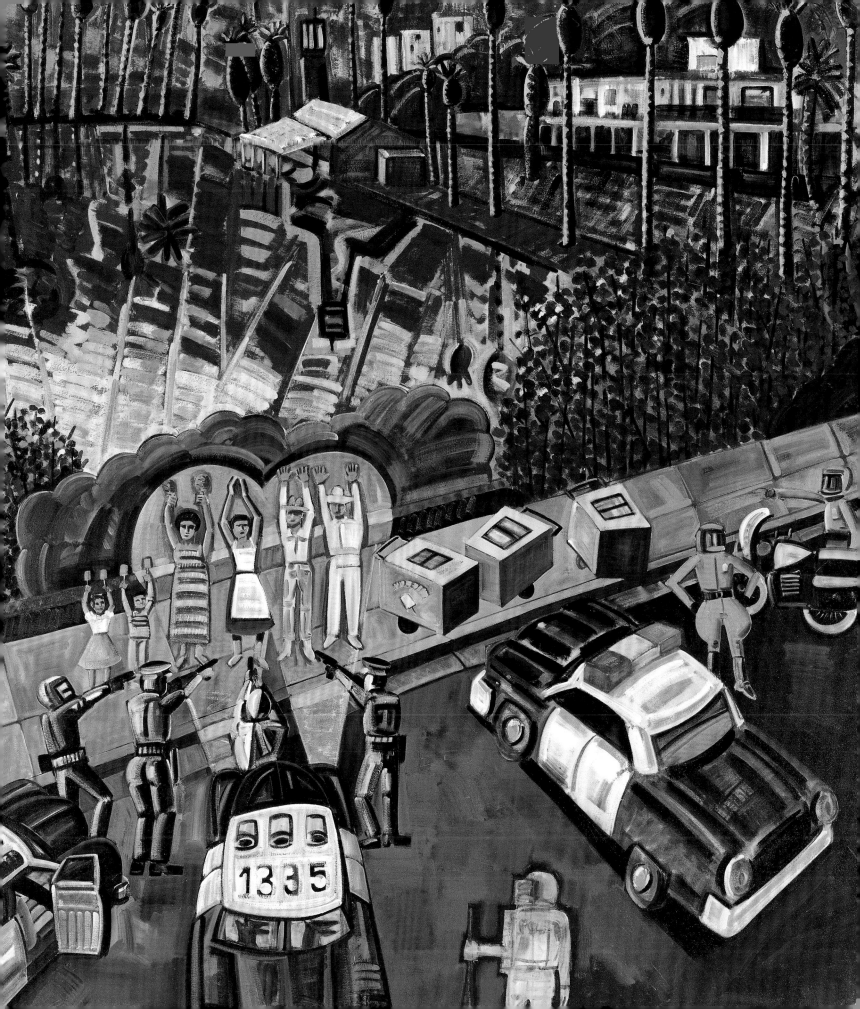

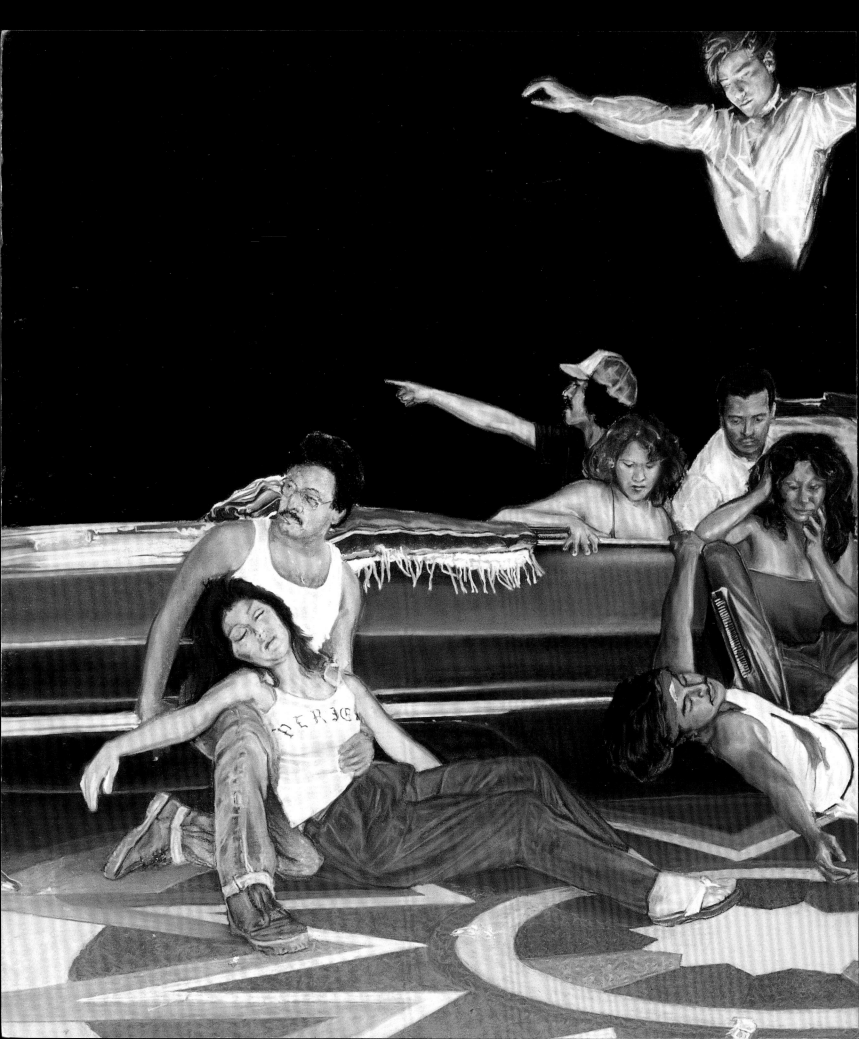

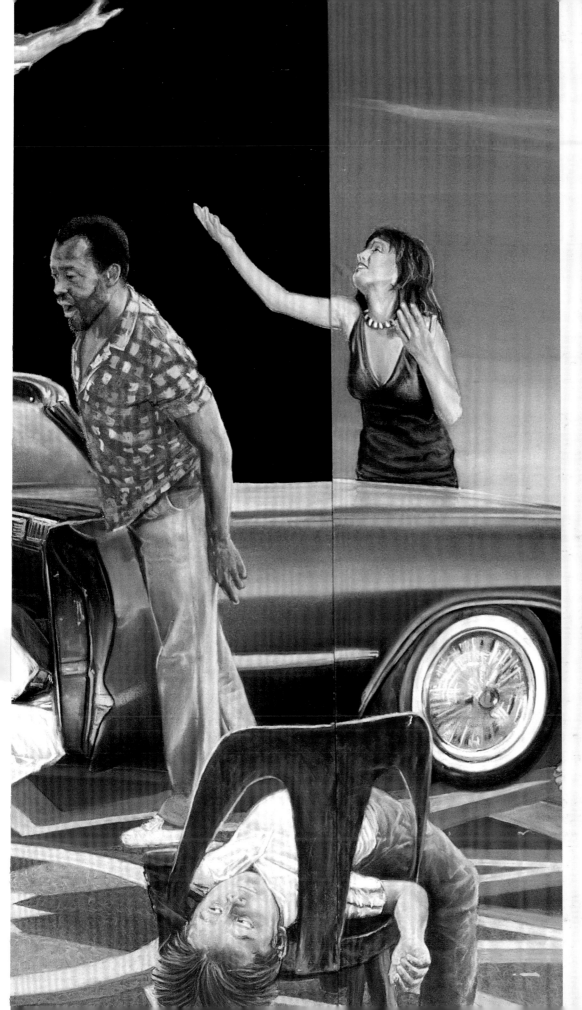

CHICANO ART:
Culture, Myth, and Sensibility

By Max Benavidez

It was late at night in City Terrace, a barrio in East Los Angeles, 1972. Willie Herron, a young Chicano artist, was walking home alone when he heard groans coming from a nearby alley. He made his way down the dark, gravelly pathway of debris and broken glass and saw his brother lying in a pool of blood.

As Herron tells it, "He had been stabbed maybe twelve times . . . tissue, blood, and stuff was coming out of him." Seeing his brother so badly hurt by gang violence filled Herron with a rush of ambivalent feelings. The next morning he walked into the bakery whose backside faced the very alley where he had found his wounded sibling and asked if he could paint a mural on the wall.

By the end of a feverish day, he had produced a stylized rendering of muscular arms bursting up through a cement street. Integrating the texture of the rough, concrete wall with angry gang graffiti into his work, Herron had distilled a situation he knew all too well, and created what would become the most famous Chicano mural in the world, *The Wall That Cracked Open*. By metaphorically breaking open the wall, the artist took the Chicano art of his time beyond illustrative poster design and into the symbolic realm.

The mural became a tour de force of Chicano art by depicting familiar Chicano imagery—the praying *madre* (mother) with her

John Valadez. *Getting Them Out of the Car*. 1984 (detail)

11

Nostalgia for Death. In the book's signature poem, "L.A. Nocturne: The Angels," Villaurrutia wrote:

Si cada uno dijera en un momento dado,
En solo una palabra, lo que piensa
Las cinco letras del DESEO formarían una enorme cicatriz luminosa,
Una constelacíon más Antigua, más viva aún que las otras.

If, at a given moment, everyone would say
With one word what he is thinking,
The six letters of DESIRE would form an enormous luminous scar,
A constellation more ancient, more dazzling than any other.

It is this yearning that holds together the personal and the political. The writer and social observer Bell Hooks tells us that, "Surely our desire for radical social change is intimately linked with the desire to experience pleasure, erotic fulfillment, and a host of other passions. . . . The sacred space of 'yearning' opens up the possibility of common ground where all these differences might meet and engage one another." For many Mexicans of Los Angeles, the 1930s were a time of intense desire for personal fulfillment and radical social change. Consider the global landscape: There was worldwide economic depression, Fascism and anti-Semitism were on the rise in Europe, and during this decade, U.S. citizens of Mexican origin were being deported to Mexico (on a one-way, government-issued train ticket) by the tens of thousands. Under those conditions, DESIRE (in every sense of that potent word) could well have been emblazoned like a giant scar in the sky above L.A.

It was into this world that in 1932, David Alfaro Siqueiros, at the time one of the world's most famous artists and a member of the Mexican Communist party, arrived in Los Angeles, in temporary exile from the travails of post-revolutionary Mexico. Contracted to teach a mural class at the Chouinard School of Art (now the California Institute of the Arts), Siqueiros's visit actually immersed him in a series of controversies that prefigured much of L.A.'s Chicano art.

While in Los Angeles, Siqueiros painted two murals that caused immediate controversy. The first, *Mitin en la Calle* (Meeting in the Street), was a fairly straightforward rendering of black and white people listening to a union organizer. Siqueiros's figures stand comfortably close together in a way that belies the racial tensions of L.A. in the 1930s. Perhaps for this reason, local response to the work was quick in coming: City residents were so outraged by the piece that it was destroyed.

The second and even more controversial Siqueiros mural was commissioned by a gallery owner who insisted on the right to pre-select the mural's theme in the aftermath of *Mitin en la Calle*'s harsh reception by the watchdogs of local culture. The last thing he wanted was the negative response that had greeted the first mural.

As the patron saw it, *America Tropical* would be a lush and placid expression of Latin America's pastoral beauty. Siqueiros, however, interpreted the theme in an entirely different way, and dedicated the mural to the Mexican working class of Los Angeles. The completed mural measured eighteen by eighty-two feet, and was painted on a second-story outer wall above the old plaza of Olvera Street. With his typical sweep of energy and motion, Siqueiros depicted a barefooted Mexican Indian strapped to a wooden cross with the rapacious talons of an American bald eagle perched above his head. Symbolically, the bound peasant—representing the city's growing brown underclass—was easy prey for the

economic appetites of the U.S. ruling classes. The plaintive and unmistakable intent of *America Tropical* again caused a backlash: The mural was whitewashed by the city, and soon afterward Siqueiros was expelled from the United States.

Although efforts are now underway to restore *America Tropical*, Siqueiros's experience set a pattern for Chicano public artistic expression in Los Angeles: Art and political comment should not be mixed in public works made by a Mexican, no matter how talented or famous. Siqueiros understood that Mexicans in Los Angeles were being treated badly, and that race, class, and exploitation insinuated themselves into the daily lives of brown-skinned, Spanish-speaking workers.

American Tropical helped frame other forms of public expression, especially gang graffiti. Although the literature is too thin to document its initial development, some observers from the time suggest that the first graffiti insignias were visible in Los Angeles as early as the 1930s, when summer heat liquefied the soft black asphalt on the streets and Mexican youth scooped it onto ice cream sticks to sign their "tag" on Eastside walls. As a form of guerrilla art, graffiti's style proclaims the presence of the angry and the unseen. Graffiti, in a sense not unlike Siqueiros and his in-your-face dismissal of a preselected theme, combines blatant defacement and disdain for the mainstream, a rejection of property rights and imposed boundaries. It is a secret code of communication by outcasts. It could even be argued that graffiti functions like conceptual and Pop art in the way that it questions the context in which art is appreciated.

Gronk, a contemporary artist who first gained attention for his mural work, has said that, "I didn't go to galleries or museums. They weren't part of my childhood. But all I had to do was walk outside my front door to see visual images all around me. Graffiti was everywhere and it helped develop a sense for what I wanted to do." Given these two visual precedents—the censored *America Tropical* and the encoded language of urban graffiti—it's no wonder that L.A.'s Chicano artists have produced politically tinged wall works as powerfully dramatic as Herron's *The Wall That Cracked Open* and as instructive as Judy Baca's *Great Wall,* with its scrupulously researched alternative history of Southern California.

Another major influence on Chicano art was the *pachuco*, the 1940s-era version of today's low-rider and a distant cousin of contemporary street gangs. Nonviolent and primarily a swaggering statement of bold style, the zoot suiter with his exaggerated clothing and long hair shaped into a pompadour served as the visual embodiment of a subculture replete with its own unique language, dress, and code of speaking. Memorialized in Luis Valdez's play, *Zoot Suit*, the *pachuco* is a symbol of the utter disregard some Mexicans felt toward mainstream cultural values. With his sartorial excesses and almost ritualized deviance, the *pachuco* allowed neither condescension nor dismissal.

For their part, most Anglos of the period who were living in the desert city of Los Angeles, had little or no frame of reference for the *pachuco*'s deviant mannerisms. Nor did the mainstream culture understand or accept the narrow set of social expression expected of Mexicans. So it was that in the early 1940s, during the war, *pachucos* rubbed against the grain of a society already on edge and by their presence disrupted society's myth of consensus. Although considered by many people in their own community to be emblems of cultural pride, the arbiters of Anglo mainstream thought the *pachucos* were ultimately out of control.

In 1943, a heat wave of media stories about juvenile crime in East Los Angeles led to a massive response by the city: U.S. soldiers stationed in the area went out into the streets and, acting like a mob, beat *pachucos* with bats, shaved their heads, stripped them naked, and left them bloodied and humiliated in full public view. The message was clear: Challenge our way of being and you will pay the price. As

noted by *Time* magazine in its June 21, 1943, issue, mob violence had become the modus operandi of law enforcement, not the citizens:

> The police practice was to accompany the caravans (of soldiers and sailors) in police cars, watch the beatings and arrest the victims. The press, with the exception of the *Daily News* and the *Hollywood Citizen News*, helped whip up the mob spirit. And Los Angeles, apparently unaware that it was spawning the ugliest brand of mob action since the coolie riots of the 1870s, gave its tacit approval.

Just as Siqueiros's work was erased from public view because it exposed American racism, the defiant *pachuco* was handled with frontier justice. The beatings, arrests, and accompanying alarmist news stories filled with stereotypical portrayals of Mexicans validated the dominant culture's ideology. Mexican insurgence, even if just a set of cocky mannerisms, style, and linguistic usage, was to be condemned. Punishment was doled out by marauding American soldiers.

During the late 1930s and throughout the 1940s, Frida Kahlo, an artist living in an outlying district of Mexico City called Coyoacán, came to prominence. Not only did Kahlo wake up the world to a new style of Mexican art, she directly influenced Chicana artists in the United States. Social rules meant little to this woman whose passions dominated her life. Being Mexican was both a devoted life mission and an art form, and she often dressed in the beautiful native costumes of the fiercely independent women of Tehuanatepec. To Kahlo, the United States was simply *gringolandia*, a place of crass materialism to be avoided at all costs.

Her work incorporated the Mexican folk art of *retablos,* small, votive paintings often made on tin as offerings to the Virgin Mary as a form of thanks for a miracle of some sort. Classic Mexican indigenous imagery also appears, such as *My Birth* (1932), in which the artist echoes an Aztec statue, circa 1500, that depicts the goddess Tlazolteotl in the act of giving birth. Kahlo's uniquely Mexican worldview, her perseverance in the face of nearly impossible odds, and her stunningly original self-portraits, piercing and almost painful to look at, are her lasting influences on Chicano art. She is the quintessential model of the union of life, art, and culture in the face of extreme adversity.

As mentioned earlier, the city of Los Angeles itself, has made a lasting impression on Chicano artists. Its center-less nodes of activity, stratified economy, social fragmentation, and anything-goes atmosphere, all factor as constructs in Chicano art, pulsing just below the surface. It's in Carlos Almaraz's exploding freeway car crashes, in John Valadez's lonely beach figures, in Patssi Valdez's ornately poignant city window displays.

Each of the precursors discussed above—Siqueiros, graffiti, the *pachucos,* Frida Kahlo, and Los Angeles—has uniquely contributed to the evolution of Chicano art. The results are five-fold:

- A critique of the status quo
- The establishment of a unique aesthetic sensibility—art measured on its own terms
- Visual demarcations between conventionally accepted cultural modes and Chicano values
- Cultural integrity and self-affirmation
- The use of montage—the bringing together of dissimilar elements into a new whole—as an essential technique

Nothing takes place in a vacuum and this is especially true for art created by a long-ignored people

who begin to question their status. As the artist and writer Harry Gamboa, Jr., once put it, "Chicanos are viewed essentially as a phantom culture. We're like a rumor in this country." The Unseen. A phantom population begins to reveal itself to the world.

A Phantom Culture Comes to Life

Most likely, Chicano art was born one day in 1965 when the late labor leader and civil rights activist César E. Chávez gave budding theater director Luis Valdez (who would later produce the play, *Zoot Suit* and direct the Richie Valens biopic, *La Bamba*) the permission to mount raw *actos*, satiric one-acts, on the picket lines of the dusty Delano fields in central California. In what would become a classic example of Chicano ingenuity, artists created a theater out of nothing. As Chávez said at the time, "There is no money, no actors. Nothing. Just workers on strike."

To make something out of nothing became the essence of early Chicano art. While the political struggle was the impetus for the movement, the arts became the means of interpretation and explanation. At the time few artists had attended art institutes and there were no government or foundation grants for ethnic artists. What the artists had was a need to say something about themselves and their community.

Spurred on by the anti-authority zeitgeist of the era, young Chicanos walked out of their substandard schools, protested the Vietnam War, in which a disproportionate number of Chicanos were being killed, and in general, rose up against a long history of injustice. Murals, like giant newspapers, proclaimed it all. Mural art filled a void by covering blank wall space with thousands of murals in housing projects, community centers, schoolyards, church halls, and storefronts. Images and themes were broad—scenes of ancient Mexican ceremonial life, farm workers on strike, blue-cloaked Virgin de Guadalupe, the value of family reading.

The blank wall became *the* space for Chicano art in Los Angeles in the 1970s. They were territorial markers and community billboards because Chicanos didn't own newspapers or radio and TV stations. To tell their stories, muralists engaged their community. Before applying paint to a wall, Chicano muralists would talk with the people who lived and worked in the area, and in so doing the artists enlisted the support of the community.

Many well-known Chicano painters such as Carlos Almaraz, Gronk, John Valadez, and Margaret García started out as muralists. One artist, Judithe Hernandez, has explained: "We tried to make murals into cultural billboards." As Willie Herron said about one of his untitled murals which shows a being who is half skeleton and half throbbing heart, "It is about the tear of two cultures, the feeling of violence and of being ripped apart by them." Whatever the actual content, Chicano murals became a form of lively dialogue between artists conveying the word about a new social revolution and a community eager to learn about it in broad strokes.

The Chicano murals of the late 1960s and early 1970s were a form of social and political literacy. The murals were the texts, the artists were the teachers or the instructors, and the members of the community were the students, readers learning about a movement otherwise ignored in the mass media of the day. Paolo Freire, the Brazilian philosopher and proponent of education for critical consciousness, would have felt right at home on a street in East Los Angeles with giant murals of farm workers and the words "Boycott Gallo" in large letters floating above the bloodshed. That is the true definition of news.

The Birth of the Chicano Sensibility

In Los Angeles, two very different Chicano art groups embodied two of the main community perspectives of the 1970s, a decade that defined Chicano art. Los Four was one of the first major groups to form in the city. It included the late Carlos Almaraz, Gilbert (Magu) Lujan, Roberto (Beto) de la Rocha, and Frank Romero. Later, the collective would count John Valadez and Judithe Hernandez as core members.

The second major art group of the period was Asco (Spanish for nausea). Gronk, Willie Herron, Patssi Valdez, and Harry Gamboa, Jr., were the original members. Other artists joined the group, often on a temporary basis, including Daniel J. Martinez and Diane Gamboa.

Asco and Los Four were inversions of one another. Los Four represented a cool, intellectual approach. Most of its members were schooled in the arts and held degrees, some advanced, from colleges and universities. Almaraz, in particular, represented the theoretical approach. As he once said, "We were opening up the definition of what Chicano was and could be." Valadez explained, "We were so starved for any kind of positive identity that any recognition of who we were, that we were even there, caused a deep response." Asco, on the other hand, symbolized the street and barrio youth. Asco members were self-taught and absorbed everything they could from TV, cartoons, foreign films, and the progenitors of performance art such as Fluxus and Andy Warhol. For Asco, there was a desire to show the truth as they lived it. As Willie Herron liked to say, "We were the true representatives of the street, the real Chicanos who were taking it all the way. We weren't romanticizing or glorifying what the streets were like. . . . We wanted to reach inside and pull people's guts out."

Although Gronk and Herron painted some of the best-known Chicano murals, they also wanted Asco to move toward public performance and spectacle. That might explain why their first major impact on the Los Angeles art world was part-performance, part-mural, employing graffiti as a form of Chicano expression. Even into the 1970s, the Los Angeles County Museum of Art (LACMA) had not exhibited the work of Chicano artists. To protest their exclusion, Asco members went to the museum late one night and spray-painted their names on the outside of the main building. As they later said, "We felt that if we couldn't get inside, we would just sign the museum itself and call it our work."

As the 1970s came to a close, Chicano artists in Los Angeles began to move in different directions. John Valadez, for one, wanted to create images with subliminal messages. He felt that it was important to develop "a way of presenting subversive images" conveyed in a "Latino visual language." With his portable mural, *The Broadway Mural* (1981), which was basically a giant canvas work, Valadez moved full force into Photorealism. The work depicts people walking through Los Angeles's main downtown drag — Broadway between 2nd and 8th streets — a busy, predominately Spanish-speaking shopping district. Wearing everyday cares on their faces and colorful casual dress, the people in *Broadway Mural* mirror the undeniable reality of Mexican Los Angeles. By the early 1980s, Los Angeles, especially the inner city, had been transformed into a Latino city. Basically, the city had been reclaimed by new immigrants, economic refugees from little villages and pueblos in Mexico, and also from poor Central American countries such as El Salvador, Guatemala, Honduras, and Nicaragua.

Valadez's Photorealist "snapshot" of Broadway spoke volumes about the new formidability of the Latin presence in the very city where four decades earlier Mexicans had been beaten and humiliated. At eighty-feet long, it is a monumental example of what Umberto Eco calls "semiotic guerrilla warfare." Valadez's maturity as an artist coincided with the changed reality of the city. A new collective voice had been born.

Chicano artists of the 1970s and early 1980s had invented a "visual language" complete with its own imagery and culturally relevant content. Theirs was a language that spoke to people within the community in terms they could understand. With allusions to Aztec mythology, everyday cultural artifact, police brutality, and gang violence, the art covered the streets of East Los Angeles with enormous marquees of pride. Most importantly, the artists proclaimed the power behind self-definition and political autonomy. As such, they assumed the roles of educator, prophet, and activist. In the process of assuming these commingled roles, the artists transformed one community's dreams into concrete reference points for social change.

Entering the Future Tense

There are certain artists who define a period—Picasso in Paris in the 1920s and 30s, Jackson Pollock and Abstract Expressionism during the late 1940s and early 50s, Gronk and Almaraz in Los Angeles in the 1980s.

Glugio Gronk Nicandro helped create the "underground" of East Los Angeles. Like many other Chicano artists, Gronk survived and flourished by acknowledging and juxtaposing images from two cultures at constant metaphysical odds with each other. His peers in the Chicano community see him as an *auteur.* A surrealist by nature and a polymorphic artist by practice, Gronk's influences range from Daffy Duck to Antonin Artaud, from Marcel Duchamp to the Mexican comic Cantinflas. Gronk and Willie Herron were responsible for some of the most memorable murals created in Los Angeles during the Chicano mural rage of the 1970s. *The Black and White Mural,* which shows excruciating scenes from a police riot in a series of black-and-white panels still exists in the Estrada Courts housing project in East Los Angeles. Others, though now gone, were often the first to show the world the emotional content of barrio life without sentiment or false hopes.

As time moved on and the world changed and became less enamored of ethnic social movements, Gronk changed and adapted, too. Although he has always recalled his street roots, he travels easily with art collectors and denizens of the gallery world. Along the way, he has kept his tongue firmly in cheek. For him, fun is serious business and everything serious is fair game for ridicule. In 1985, Gronk invited the art world, critics, and curious onlookers to take a metaphorical voyage on the ill-fated Titanic. In an exhibition called "The Titanic and Other Tragedies at Sea," he painted images of the mindless frolics of the upper classes and used the concept of the *Titanic,* that manmade folly of the Industrial Age, as a metaphor for the U.S. during the Reagan years. In what would become a recurring obsession for Gronk, he took viewers on a satirical voyeur's tour through a world of opulent excess.

It was also during this period that he perfected his renowned temptress, La Tormenta. Perhaps from her name we can assume that she is the one who torments. Whether it is the artist or the awestruck viewer that she afflicts or both does not matter. She is always the faceless one, her chalk-white back to the viewer, the femme fatale in the backless dress who glides through Gronk's worlds like a specter of reptilian temptation and irresistibility. The case could be made that Tormenta is none other than Gronk himself, his anima, his feminine self, dressed to kill and to impress. (See Panel I of *La Tormenta Returns* for one treatment of this familiar Gronkism, page 76.)

In the late 1980s, he began creating shows around the concept of hotels. In 1988, for example, he put forth "Grand Hotel," the first in a series of exhibitions that used this symbol of life's transitory nature. His initial inspiration was the time that he spent living in the Grand Hotel, a way station in downtown Los Angeles not far from his loft. "I did research," Gronk explained. "I needed to know what it was like to live

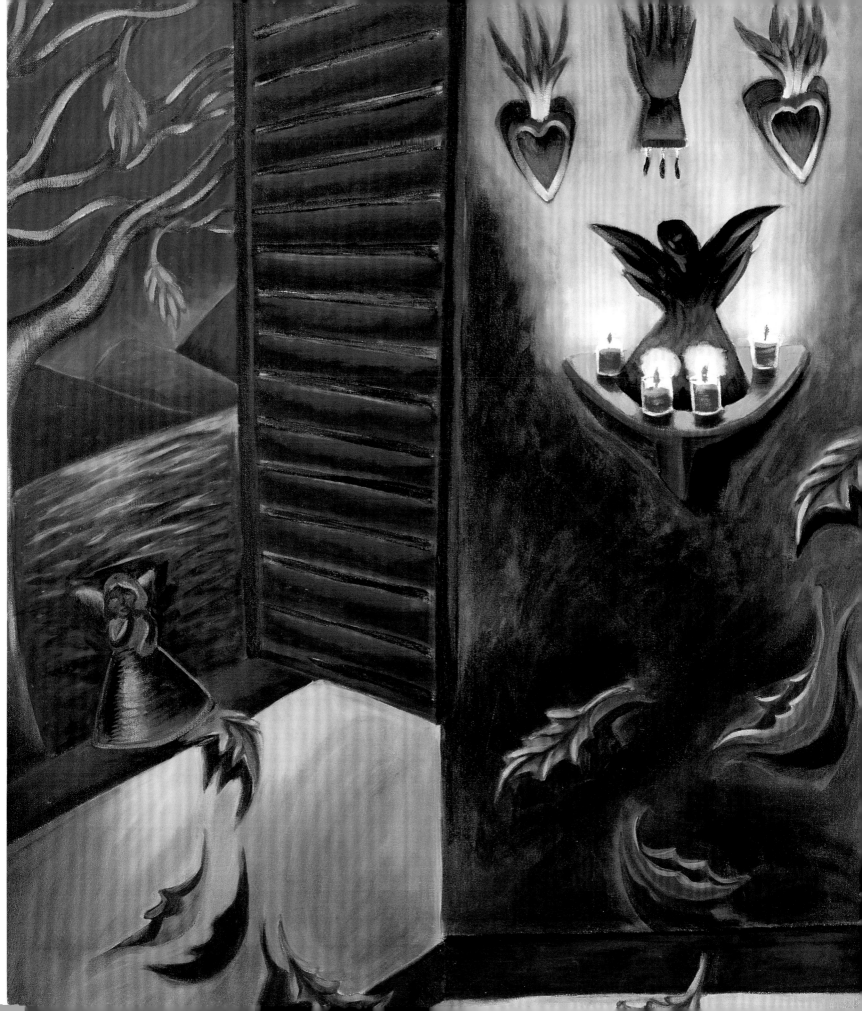

MESTIZA AESTHETICS AND CHICANA PAINTERLY VISIONS

By Tere Romo

Because I, a mestiza,
continually walk out of one culture
and into another,
because I am in all cultures at the same time.
—Gloria Anzuldua

The Chicano Movement of the late 1960s and 1970s also marked the beginning of Chicano art as artists abandoned individual careers and became the visual articulators of the movement's political agenda, mainly through the creation of posters and murals. By articulating the movement's political stance, artists also had as their central goal the formation and affirmation of a Chicano identity. "Self-representation was foremost in that phenomenon, since self-definition and self-determination were the guiding principles . . . of a negotiated nationalism."[1] In visualizing this new identity, artists became part of a cultural reclamation process that expanded the definition of Art to include all the arts that affirmed and celebrated their Mexican cultural heritage, including pre-conquest symbols, religious icons, popular art forms, murals, and graphic arts.[2] The result was an iconography of new images and symbols derived from a Mexican *mestizo* (mixed race) heritage, yet forged within an American, bicultural experience.

Patssi Valdez. *Autumn.* **2000 (detail)**

23

As a result of this syncretism a distinctly Chicano aesthetic emerged, much of it during the first decade tied to a nationalist, political agenda. The early iconography combined easily identifiable heroic figures with images from a glorious past and transformed them into artworks that were relevant and culturally affirming. From its inception, Chicano art was heavily male-dominated and this was reflected in the predominant imagery. "At that time, a lot of the images were of men," recalled visual artist and muralist Irene Perez. "All the heroes were men and it seemed like historical events only happened to men, not to families or communities."[3] Although the movement's leaders called for ethnic and racial equality, the need for gender parity in the areas of leadership and decision-making was often overlooked. Within the Chicano Art Movement, artist collectives and centers were overwhelmingly male. Those that did include women usually had one or two members and none of them in leadership positions. As artists, Chicanas found themselves contending not only with the mainstream's patriarchal system, but also with the movement's own brand of machismo.[4]

Chicana artists turned their exclusion into an advantage as they pursued their own artistic path and visibility. From the beginning, as Chicano artists strove to utilize art as an active tool of socio-political mobilization, propaganda, and empowerment, Chicana artists chose a less conformist approach to art making. Chicanas also tackled gender politics. Consequently, subject matter such as motherhood, regeneration, and female ancestry became part of a formal and ideological basis for a Chicana aesthetic in the early years of the Chicano Art Movement.[5]

As Chicana artists continued to experiment with different media and iconography, they found themselves outside the definitions of Chicano art as constructed by males. Chicana art was perceived as non-political (lacking a political message), too personal (rather than community focused), and pro-religion (too Catholic). However, a closer reading of Chicana art reveals the same principles underlying Chicano art: political resistance, cultural affirmation, and bicultural identification. As women, Chicanas also asserted their right to create an art meaningful to them. According to scholar Amalia Mesa-Bains,

> The work of Chicana artists has long been concerned with the roles of women, questioning of gender relations, and the opening of domestic space. Devices of paradox, irony, and subversion are signs of the conflicting and contradictory nature of the domestic and familial world within the work of Chicana artists.[6]

Through a conflation of subversive imagery, content (message) and art process, a distinctive Chicana aesthetic evolved that was grounded in Chicano ideals and artistic integrity, yet molded by a conscious resistance to restrictive so-called female roles as defined in relation to male needs, desires, or projections. Feminist theorist Griselda Pollack writes, "The spaces of femininity . . . are a product of a lived sense of social relatedness, mobility and visibility in the social relations of seeing and being seen."[7] Having begun with the recuperation of their feminine persona with materials and scenes from the domestic sphere, by the late 1970s Chicana artists freely explored a myriad of media and fully exploited metaphorical and ironic elements within their art. Some Chicana artists experimented with installation art, photography, performance art, box constructions, and other art forms that expanded their abilities to rework and reconstruct identity utilizing familiar materials. An example of this was the transformation of private home altars into contemporary public art installations by Amalia Mesa-Bains, Carmen Lomas Garza, and Patssi Valdez, among others.

Even within the seemingly safe world of painting, Chicana artists defied the mainstream's art canon

in the creation of their own *mestiza* aesthetics. An excellent representation of these distinct aesthetics can be seen in the artwork of the Chicana painters featured in the following pages. There are similar experiences that unite Diane Gamboa, Margaret García, Carmen Lomas Garza, Ester Hernández, Marta Sánchez, and Patssi Valdez. They are all from working class families and born roughly within the same decade. Each artist has had some art school training and most of them have received fine arts degrees. Understandably, major differences inform their artwork. Valdez, Gamboa, and García were born and raised in the urban environment of East Los Angeles. Hernández was born in California's rural central valley into a migrant farm worker family. Garza and Sánchez are both from South Texas (Kingsville and San Antonio, respectively). While it is true that Garza, Hernández, and Sánchez left their places of birth to pursue higher education and live in major cities (San Francisco and Philadelphia), their early regional influences are key to an understanding of their art. This geographic balance provides a good grounding for the discussion of the work of each of the painters and a point of departure for each artist's contribution to what I call "*mestiza* aesthetics of clarity."

The search for artistic clarity is hardly a new concept for painters. From its early beginnings on cave walls, painting has struggled to articulate what an artist deems important. This is the clarity that belongs to the surrealists' attempt to make the unconscious visible or Rothko's attempts to paint God. The *mestiza* aesthetics of clarity as honed and practiced by Chicana painters, however, are based on the visual transformation of their socio-political and gender experiences driven by their artistic vision. Rather than a prescribed search for beauty, or an "art for art's sake," their aesthetic is based on the *process of making clear that which by definition is melded.* For these painters, the creation of their art is the exposure of imperfections, whether it is ethnic stereotypes, gender restrictions, or personal demons in order to provide a more inclusive and cohesive understanding of another valid reality. In the course of their artistic explorations, they have created their own visual language of cultural resistance and personal transformation.

The artists represented here paint in styles ranging from near abstraction to realism, yet all their work can be described as variations of portraiture. As metaphoric self-portraits or realistic recreations of community activities, this portraiture becomes a form of cultural survival and personal regeneration. In fact, for these Chicana artists there is no distinction between the importance of art in personal and community survival. To express her vision is to bring visibility to not only herself and her artistic voice, but also to the community that the Chicana artist is a part of and represents.

Urban Reflections Through the Chicana Looking Glass: Patssi Valdez, Diane Gamboa, and Margaret García

Los Angeles has the distinction of being one of the largest cities in the United States and the birthplace of the Hollywood industry that continues to impact the world. Los Angeles is also home to the largest concentration of Mexicans outside of Mexico. It has been noted that someone can live in Los Angeles all his or her life and never have to learn English. During the Chicano movement, L.A. was an epicenter of political mobilization by students, Vietnam anti-war demonstrators, and labor activists. It was during this volatile period of the Brown Berets' formation, high school student walkouts, United Farm Workers Union picket lines, and the Chicano Moratorium that Patssi Valdez, Margaret García, and Diane Gamboa found their artistic voice.

Patssi Valdez began her art career as a member of the seminal group Asco while still in high school.

AZTLÁN IN TEJAS: CHICANO/A ART FROM THE THIRD COAST[1]

By Constance Cortez

The concept of Aztlán[2] was introduced during the 1960s as both a geographic and a symbolic locale around which Chicanos/as could rally. It quickly became a conceptual driving force behind much of the art produced during this era, especially in California. Even so, aspects of Aztlán had resonance throughout the Southwest. The Aztlán addressed here is located far from California—it is the Aztlán of the "Third Coast." The phrase *Third Coast* requires some explanation, since it is not used outside of Texas. As the thinking goes, there is the East Coast, there is the West Coast, and there is Texas, the Third Coast, which faces neither the Atlantic nor the Pacific oceans. Rather, it faces the Gulf of Mexico. Texas and its inhabitants share waters as well as borders with Mexico. Beyond that, the state's past and present are inextricably joined with that of Mexico's.

As in the case of Mexico, there is no one Texas. Bravado aside, the fact remains that TEXAS-IS-A-REALLY-BIG-PLACE. The intracultural diversity between Chicano populations is as marked, if not more marked, than that existing between Los Angelino and San Franciscan communities. These regional differences, as well as differences in personal visions, provide the bases for radically different art styles among the

Adan Hernández. *Sin Título II.* 1988 (detail)

uninflected background, the subject is situated in time only by means of personal dress and actions. The land itself remains immutable in its nature.

These artists from Aztlán share an extraordinary sense of this land. At the same time, they are acutely aware that the topography through which they travel goes far beyond any simple geographic designation or shared set of experiences. Some of the artists explore life in large cities and comment upon urban plights such as racism and violence. By critiquing these realities, their works go beyond the aesthetic—they reaffirm and give voice to those who share such experiences while conveying an alternative reality to those who do not share these experiences. For other artists working on the Third Coast, Aztlán can provide a stage on which to play out and explore memories born of family histories and legend. Spirituality, politics, and a basic exploration of human nature are all given context by an overarching sense of land, space, and time.

Bibliography

Corpus Christi Caller Times. Monday, Dec. 22, 1997. Interactive webpage: www.caller.com/newsearch/news10144.html

Grant, Mary Lee. "Don Pedrito still attracting visitors after almost 90 years. "*Corpus Christi Caller Times.* Monday, Dec. 22, 1997. Interactive web page: *www.caller.com/newsearch/news10144.html*

Hernández, Adan. Artist web page, http://members.aol.com/Adanarte.html.

Herrera-Sobek, María, ed. *Santa Barraza, Artist of the Borderlands.* College Station: Texas A&M Press, 2001.

Laguna Gloria Art Museum. *Mel Casas.* (introduction by Dave Hickey). Austin, Tex.: Laguna Gloria Art Museum, 1988.

Leal, Luis. "In Search of Aztlán" in *Aztlán: Essays on the Chicano Homeland,* ed. Rudolfo A. Anaya and Francisco A. Lomelí. Albuquerque, N.M.: University of New Mexico Press, 1989.

Lomas Garza, Carmen. *In My Family/En mi familia.* (Paintings and Stories by Carmen Lomas Garza as told to Harriet Rohmer). San Francisco: Children's Book Press, 1996.

Quirarte, Jacinto and Carey Clements Rote. *César A. Martínez: A Retrospective.* San Antonio, Tex.: The Marion Koogler McNay Art Museum, 1999.

Ybarra-Frausto, Tomás and Terecita Romo. *Carmen Lomas Garza: Lo Real Maravilloso (The Marvelous/The Real).* San Francisco: The Mexican Museum, 1987.

Notes

1. Special thanks to the artists who took the time to speak to me regarding their works and to my colleagues, Patricia Reilley and Andrea Pappas, who listened to and critiqued an early version of this article.
2. In 1968, the poet Alurista mentioned the concept of Aztlán to his class at San Diego State University; a year later, Rodolfo 'Corky' Gonzáles introduced it to the general public at Chicano National Liberation Youth Conference held in Denver, Colorado. Leal, 11.
3. Leal, 8.
4. ibid.
5. This is now Texas A&M University, Kingsville.
6. Ybarra-Frausto, 7.
7. ibid, 9.
8. Lomas Garza, n.p.
9. ibid.
10. A *curandero/a* is a medicinal practitioner who uses a combination of spirituality and herbs to cure patients. See Grant, Dec. 22, 1997.

11. Herrera-Sobek, 28.
12. ibid., 13.
13. Hickey, in *Mel Casas,* 6.
14. Casas, telephone interview with author, May 24, 2001.
15. According to Casas, the flag represents extreme measures, but they are measures which are taken out of necessity. Casas, telephone interview with author, May 24, 2001.
16. Casas, telephone interview with author, May 24, 2001.
17. Quirarte, 22.
18. Martínez, interview with author, May 25, 2001.
19. ibid.
20. Martínez, interview with author, May 25, 2001.
21. Casas, interview with author, May 24, 2001.
22. Hernández, interview with author, May 24, 2001.
23. *http://members.aol.com/Adanarte.html*
24. letter to author from Sánchez, March 17, 2001.

THE PLATES

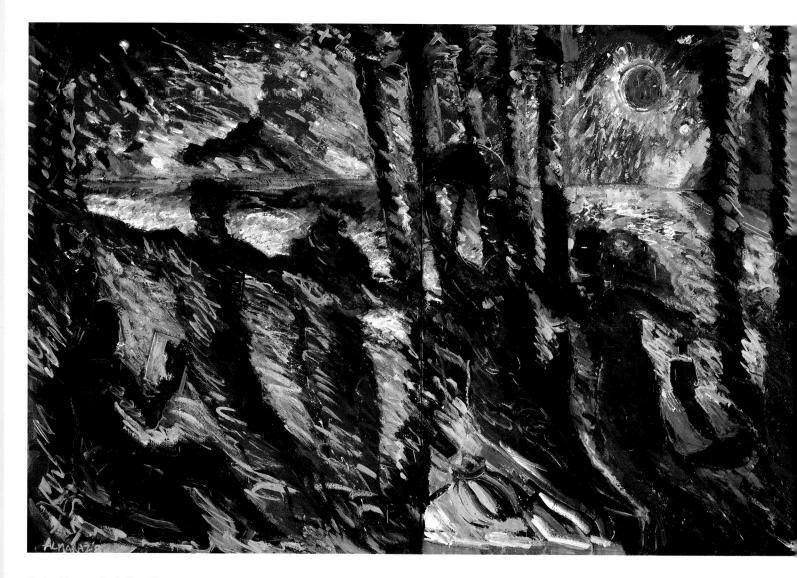

Carlos Almaraz. *Early Hawaiians*
(triptych). 1983. Oil on canvas, 163 x
72" overall. Collection Los Angeles
County Museum of Art. Gift of
William H. Bigelow, III. M.91.288 a-c.
© 2002 The Carlos Almaraz Estate

*Almaraz's virtuoso ability to put paint on canvas is like listening to
John Coltrane or any other great jazz player.*

Almaraz wanted to get a feel for the thickness and texture of the paint, so he approached the painting as though it were a piece of sculpture.

Carlos Almaraz. *Creatures of the Earth.* **1984. Oil on canvas, 35 x 43".**
Collection Cheech and Patti Marin

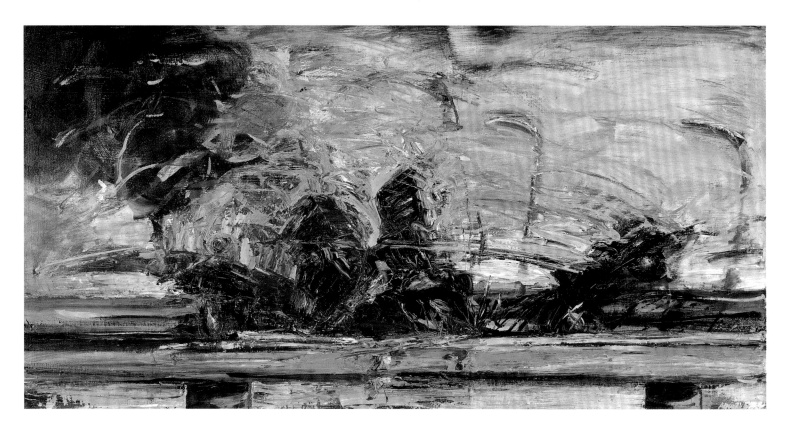

Carlos Almaraz. *Flipover.* 1983.
Oil on canvas, 72 x 36". Collection
Mrs. Liz Michaels Hearne and John
Hearne

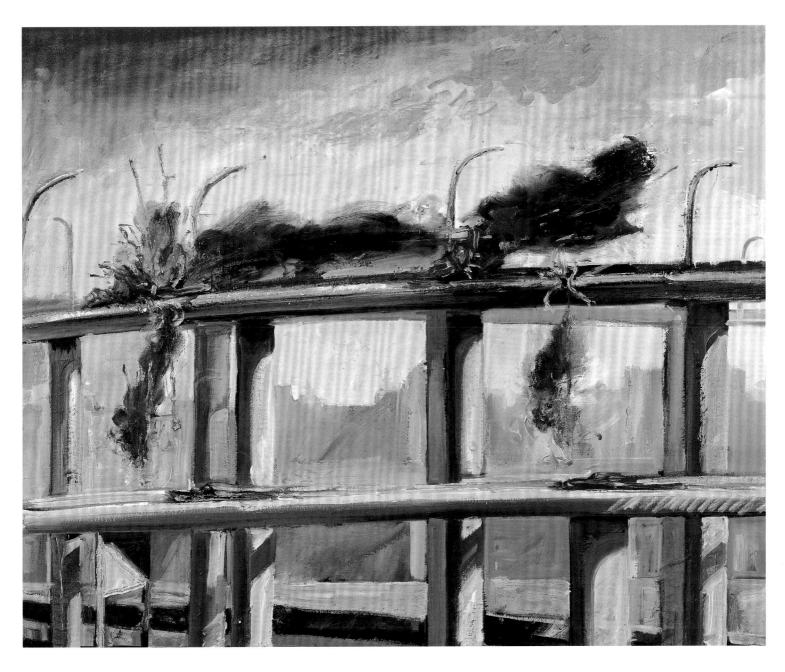

Carlos Almaraz. *Sunset Crash*. 1982.
Oil on canvas, 43 x 35". Collection
Cheech and Patti Marin

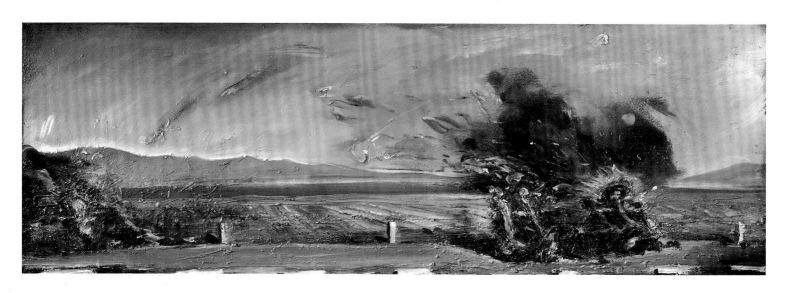

Carlos Almaraz. *West Coast Crash.*
1982. Oil on canvas, 54 x 18".
Collection Elsa Flores Almaraz

West Coast Crash, detail

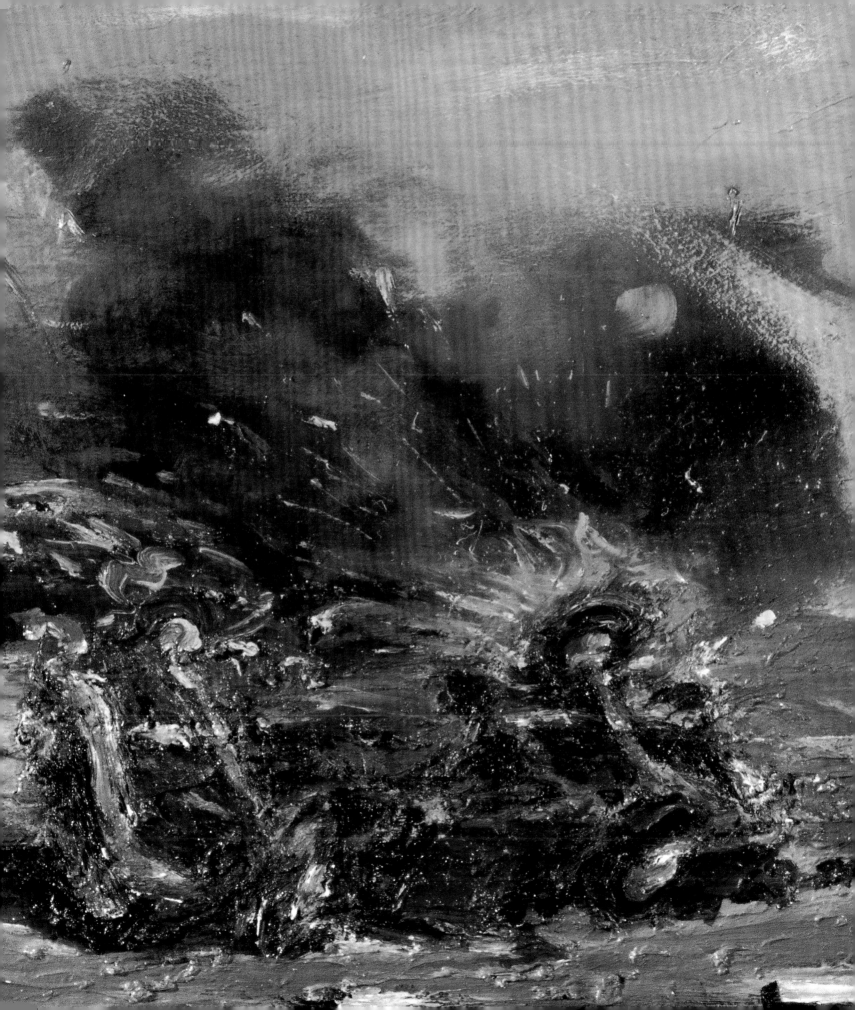

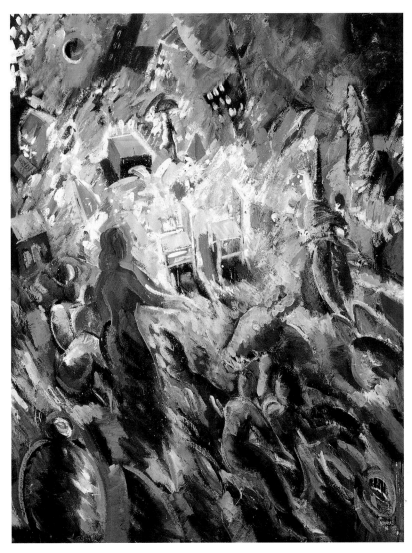

Carlos Almaraz. *The Two Chairs*.
1986. Oil on canvas, 66 x 79½".
Collection Cheech and Patti Marin

The meaning of this painting always puzzled me until a friend told me of the saying, "You can't sit on two chairs at the same time."

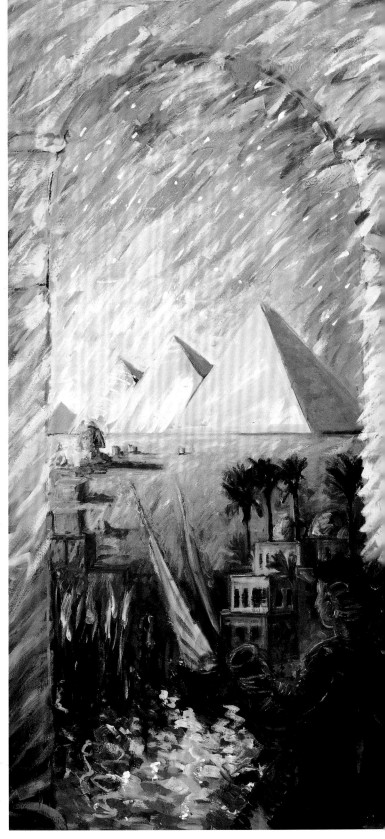

Carlos Almaraz. *Pyramids* (triptych).
1984. Oil on canvas, 144 x 96" overall.
Collection Cheech and Patti Marin

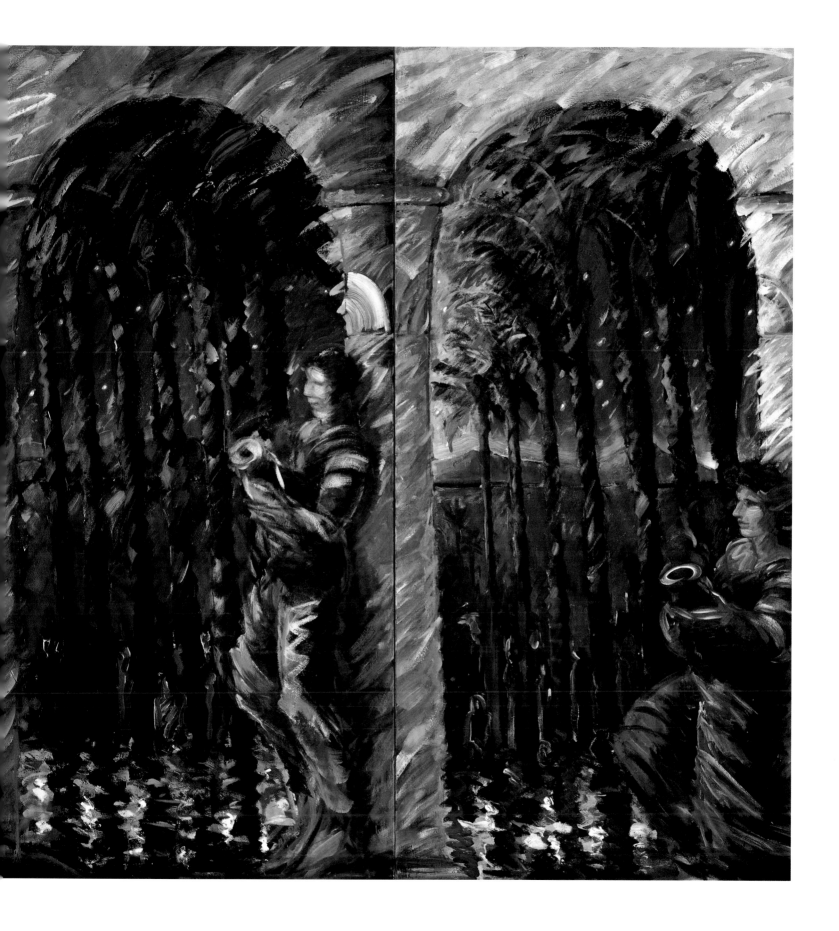

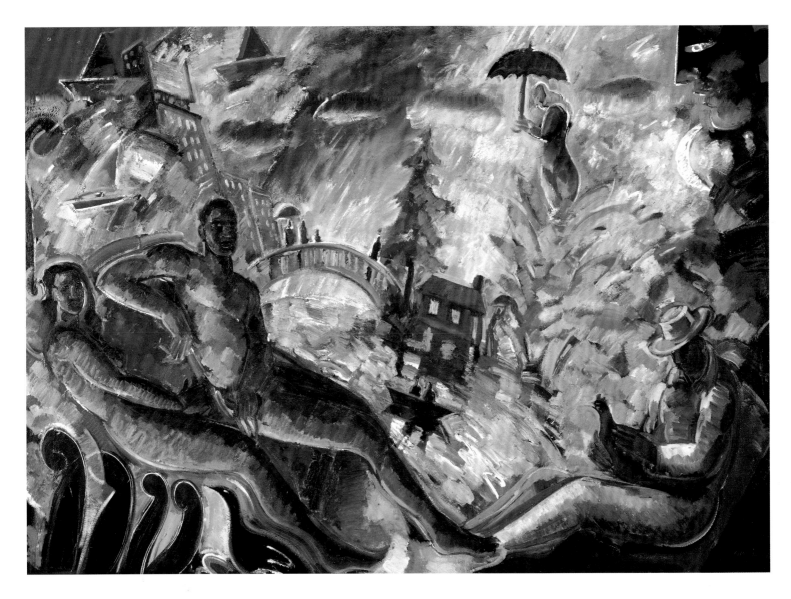

Carlos Almaraz. *California Natives*.
1988. Oil on canvas, 84 x 60".
Collection Cheech and Patti Marin

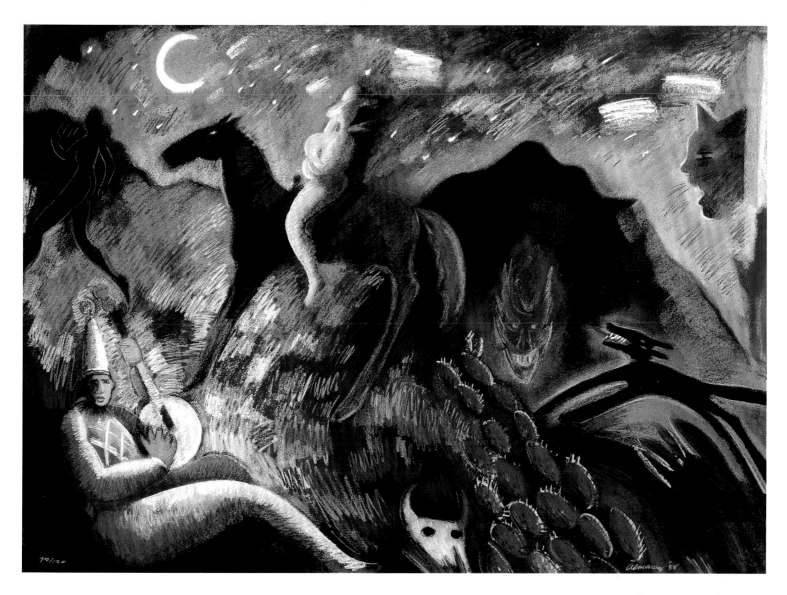

Carlos Almaraz. *Southwest Song*.
1988. Serigraph, 48 x 34½".
Collection Cheech and Patti Marin

Chaz Bojórquez. *Words That Cut.*
1991. Acrylic on canvas, 92 x 65".
Collection Nicolas Cage

Chaz Bojórquez. *Chino Latino*. 2000.
Acrylic on canvas, 72 x 60".
Collection Cheech and Patti Marin

Bojórquez advances graffiti art with the introduction of calligraphy, which he studied extensively.

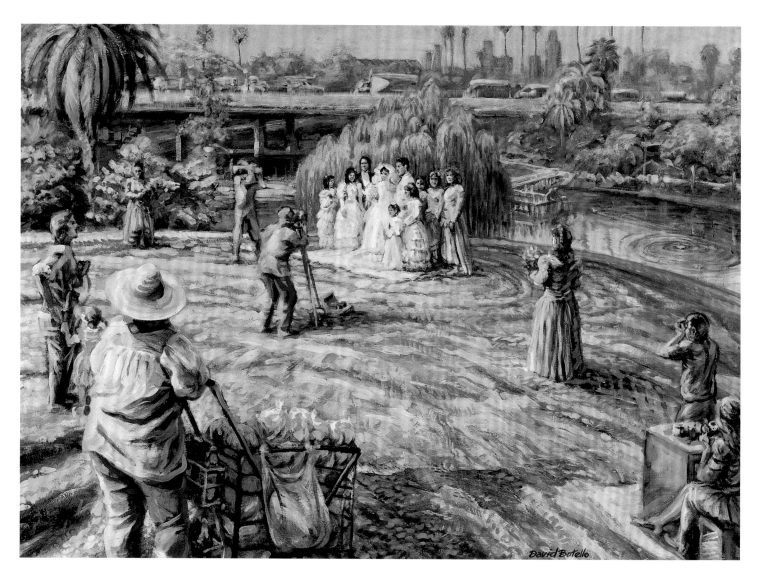

David Botello. *Wedding Photos—Hollenbeck Park*. 1990. Oil on canvas, 47½ x 35¼". Collection Cheech and Patti Marin

Botello is the colorist for the East Los Streetscrapers, a mural and pubic works group that is responsible for some of the most famous murals in East L.A. and other parts of the country. Both this painting and the one opposite equally depict the celebratory and shadowy aspects of one of the best-known parks in East L.A.

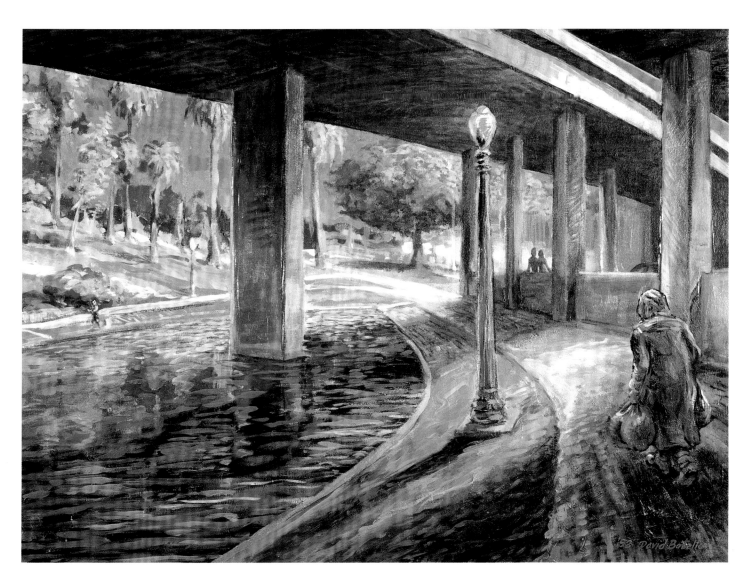

David Botello. *Alone and Together Under the Freeway*. 1992. Acrylic on canvas, 34 x 25". Collection Cheech and Patti Marin

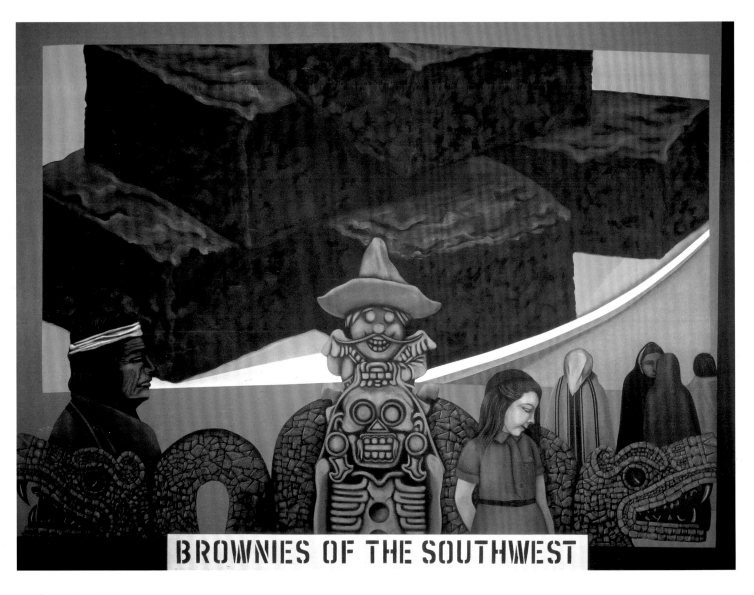

BROWNIES OF THE SOUTHWEST

Mel Casas. *Humanscape 62*
(Brownies of the Southwest). 1970.
Oil on canvas, 97 x 73". Collection
the artist

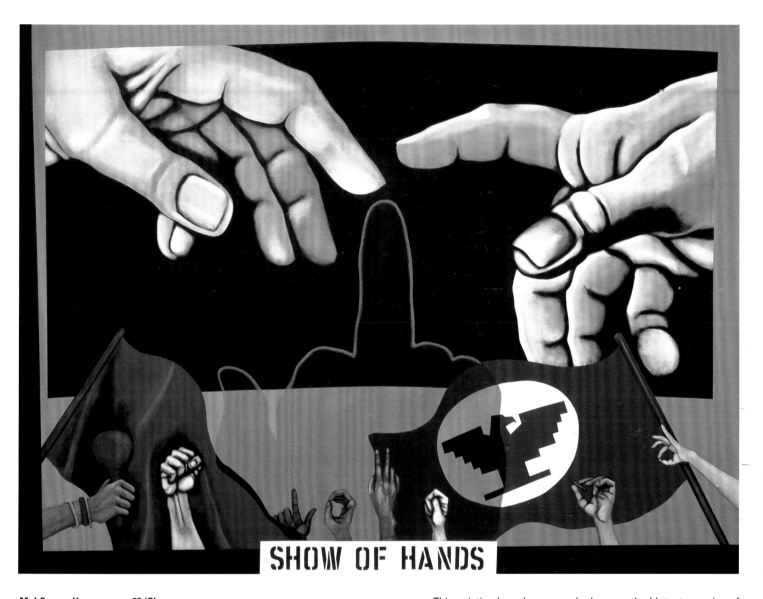

SHOW OF HANDS

Mel Casas. *Humanscape 63 (Show of Hands)*. **1970. Oil on canvas, 97 x 73". Collection the artist**

This painting has always cracked me up: the blatant meaning of the finger is ironically contrasted with the subtlety of being rendered as a silhouette. Chicanos have always demonstrated a sense of humor in the face of adversity.

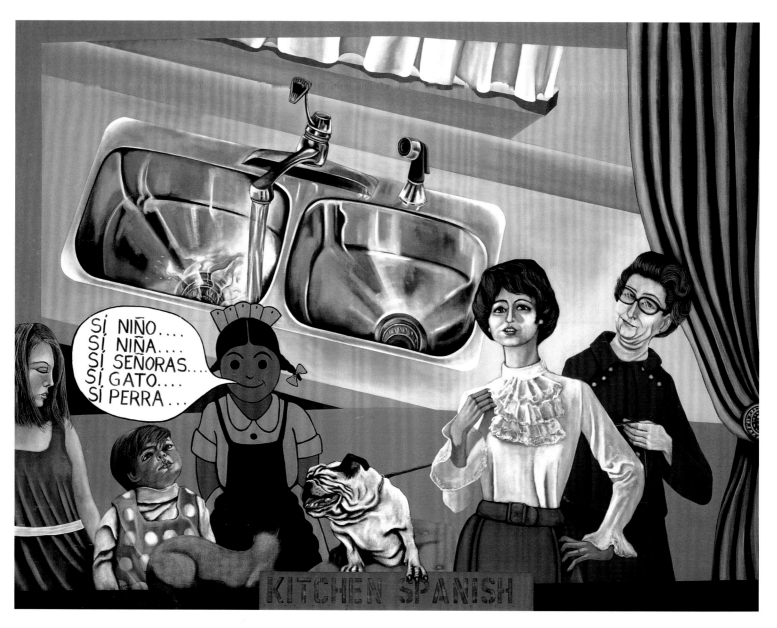

Mel Casas. *Humanscape 68 (Kitchen Spanish)*. 1973. Oil on canvas, 97 x 73". Collection the artist

Artist's statement: Communication has been a pursuit of all humans since the beginning of time. Like people of every culture, Mexican-Americans—in particular those in west Texas and East Los Angeles—developed a form of communication marked by creativity and diligence. They call it "Tirando Rollo," an expression that originated in Calo, a language adopted by el Pachucismo in the 1940s. As communication, *Tirando Rollo* takes various forms: telling a story, chatting aimlessly, or speaking earnestly with a friend. An especially remarkable form of *Tirando Rollo* can be spotted daily in El Paso, Texas, a border community directly across the Rio Grande River from Mexico. There, along the perimeter of the county jail, wives, girlfriends, relatives, and friends of the inmates gather on the sidewalks and gaze at the narrow windows of the jail. Unable to connect through traditional means, visitor and inmate alike transcend their separateness and communicate through elaborate arm gestures, proving once again that heartfelt communication can never be denied.

Gaspar Enríquez. *Tirando Rollo (I Love You)* (triptych). 1999. Acrylic on paper, 81 x 58" overall. Collection Cheech and Patti Marin

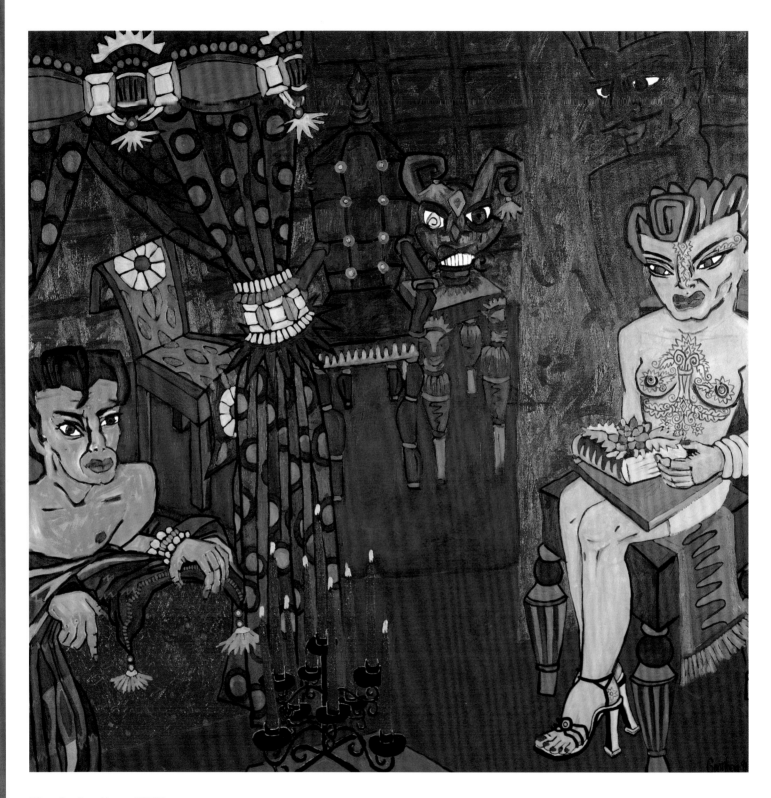

Diane Gamboa. *Tame a Wild Beast.*
1991. Oil on canvas, 54 x 54".
Collection the artist

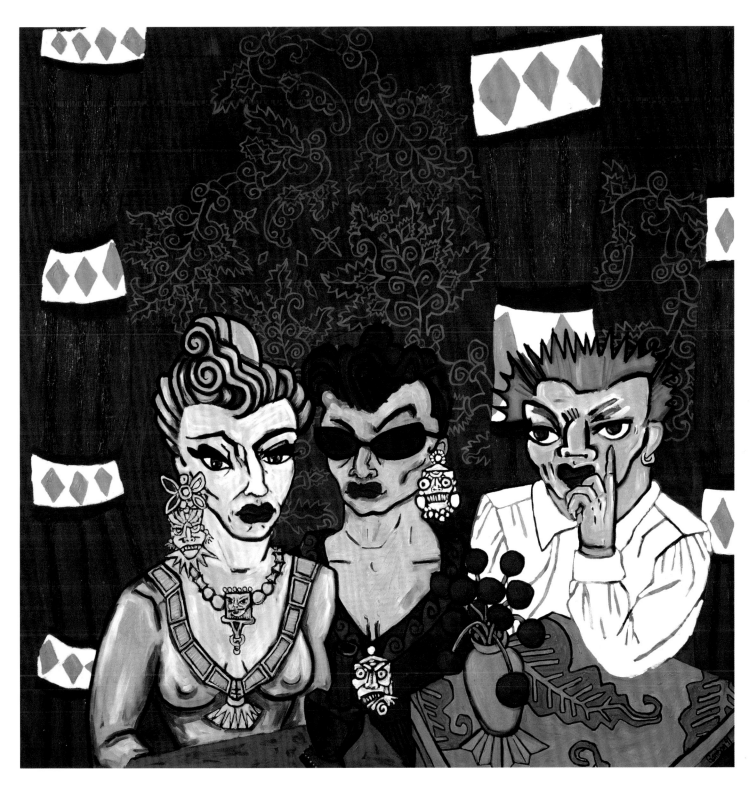

Diane Gamboa. *Time in Question*.
1991. Oil on canvas, 54 x 54".
Collection the artist

Diane Gamboa. *Green Hair*. 1989.
Oil on paper, 18 x 25". Collection
Cheech and Patti Marin

Diane Gamboa. *She Never Says Hello.* 1986. Mixed media on paper, 24 x 36". Collection Cheech and Patti Marin

Margaret García. *Eziquiel's Party*.
2000. Oil on canvas, 54¼ x 44¾".
Collection Cheech and Patti Marin

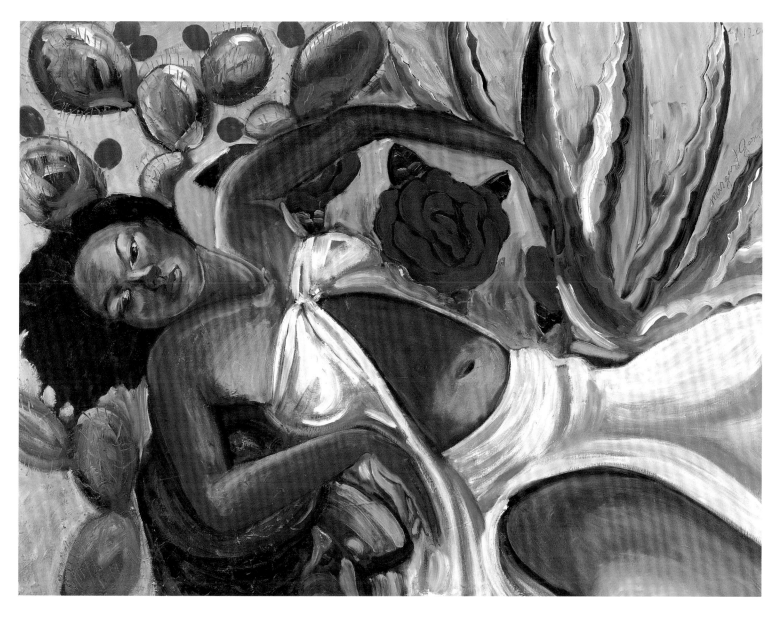

Margaret García. *Janine at 39,*
Mother of Twins. 2000. Oil on
canvas, 47½ x 35½". Collection
Cheech and Patti Marin

If there is a visual definition of the lushness, the strength, and the
beauty of women, this painting is it.

Margaret García. *Un Nuevo
Mestizaje Series* (The New Mix).
(16 works). 1987–2001. Oil on
canvas, oil on wood, 96 x 96"
overall. Collection the artist

Un Nuevo Mestizaje Series
(The New Mix), detail

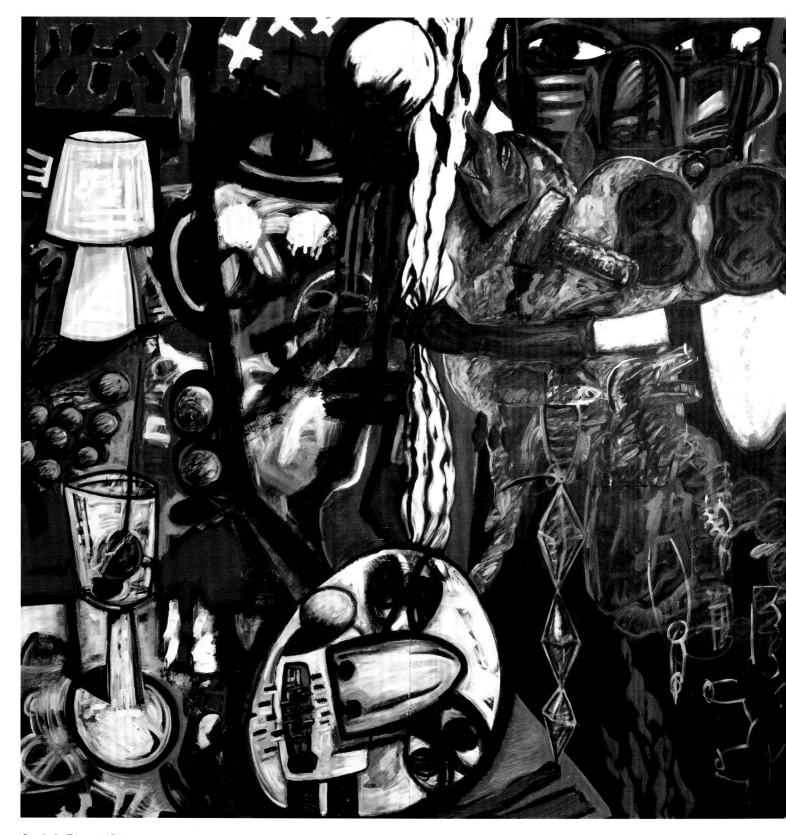

Gronk. *La Tormenta Returns*
(triptych). 1998. Acrylic and oil on
wood, 144 x 96" overall. Collection
Cheech and Patti Marin

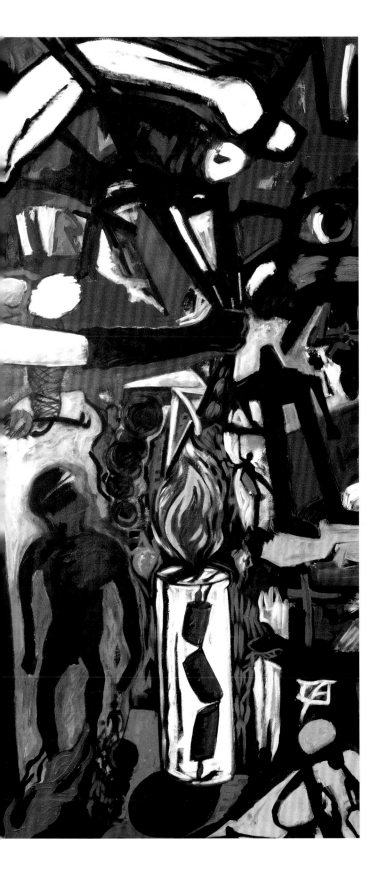

Painted live in front of an audience in San Francisco accompanied by the Kronos Quartet.

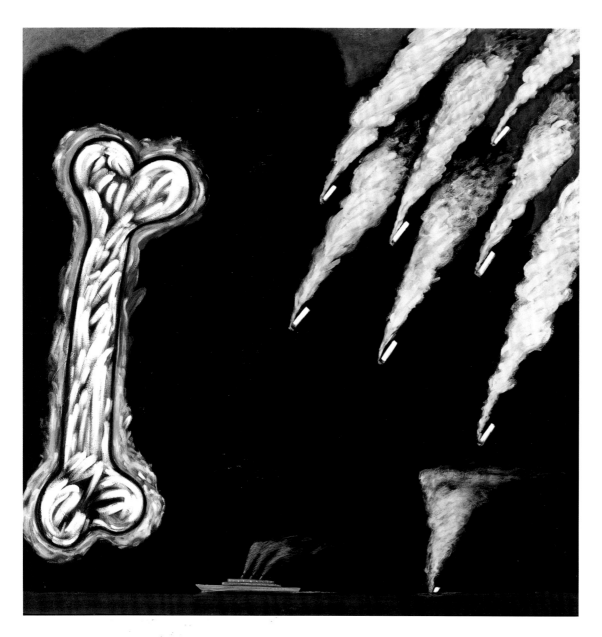

Gronk. *Getting the Fuck Out of the Way*. 1987. Oil on canvas, 48 x 48".
Collection Cheech and Patti Marin

Gronk. *Josephine Bonaparte Protecting the Rear Guard*. 1987. Acrylic on canvas, 60 x 72". Collection Joanna Giallelis

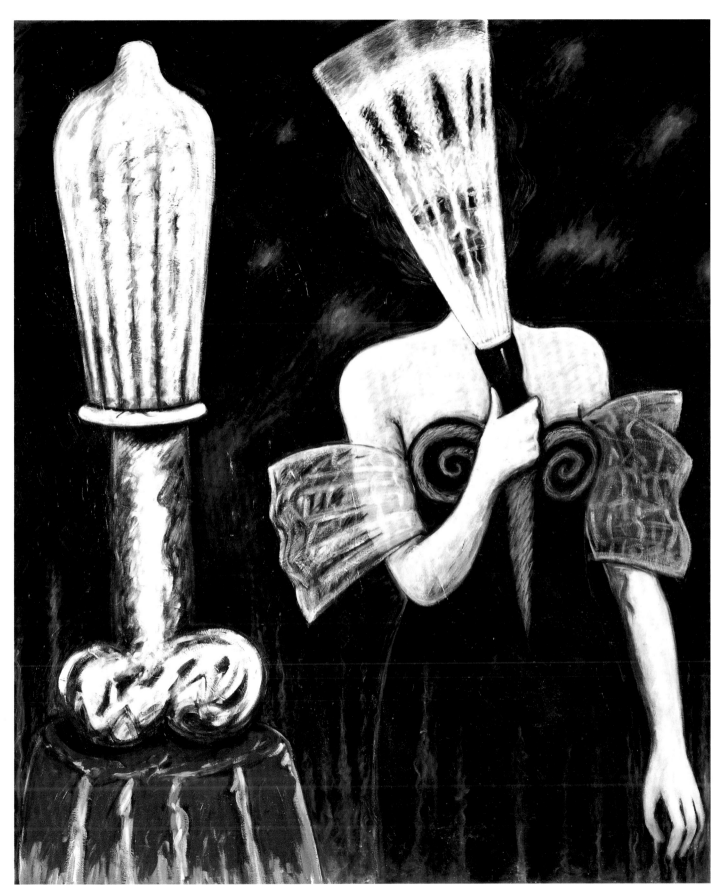

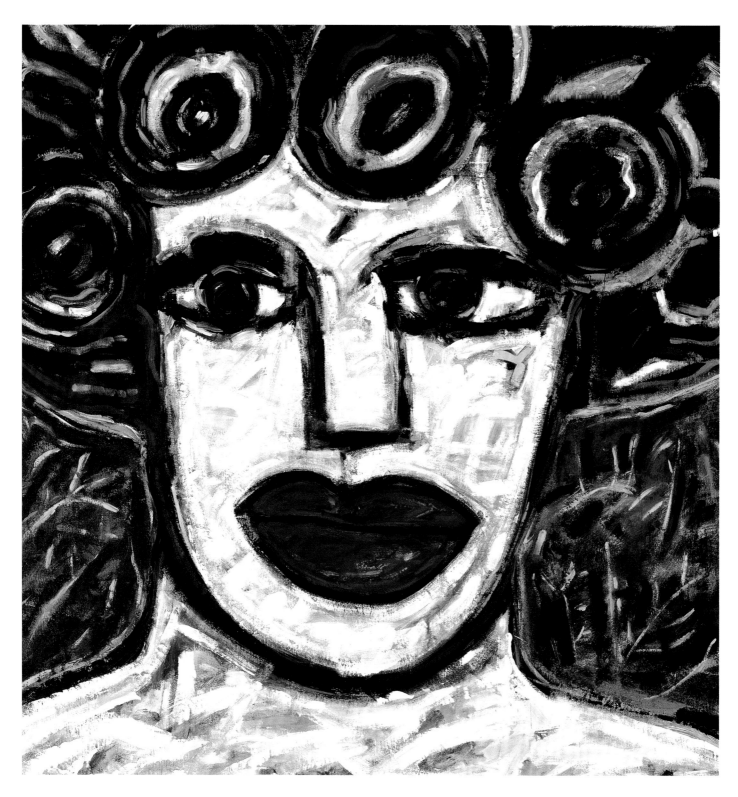

Gronk. *Hot Lips*. 1989. Acrylic on
canvas, 67 x 70". Collection William
Link and Margery Nelson

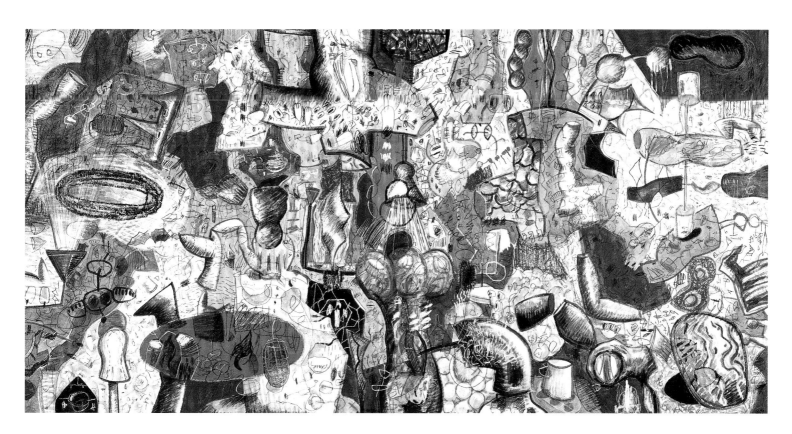

Gronk. *Pérdida (ACCENT ON THE e)*. (Lost). 2000. Mixed media on hand-made paper mounted on wood, 118 x 60". Collection Cheech and Patti Marin

The natural evolution for Gronk into Chicano abstraction as the background moves into and becomes the foreground.

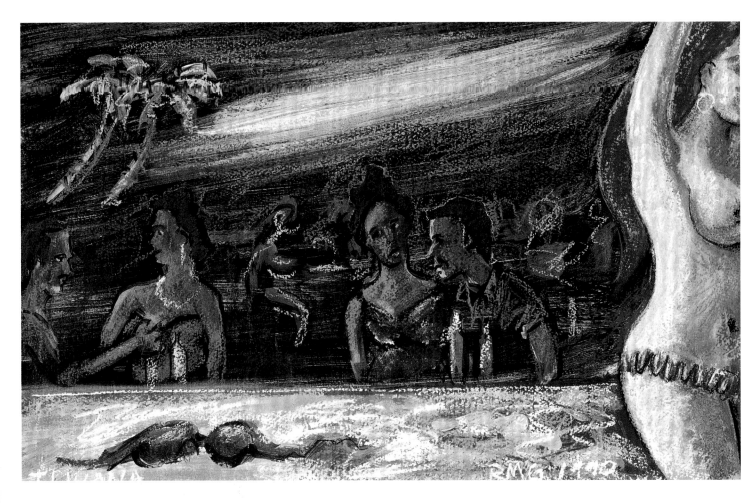

Raul Guerrero. *Club Coco Tijuana.*
1990. Gouache and chalk pastel on
Arches paper, 22¼ x 14¼".
Collection Cheech and Patti Marin

This pastel and Molino Rojo, *opposite, recall my youthful experiences in border town Tijuana, where I first experienced nightlife in bars and cafés. The pastel dance halls made by Henri Toulouse-Lautrec and Edgar Degas also reminded me of these wilder days.*

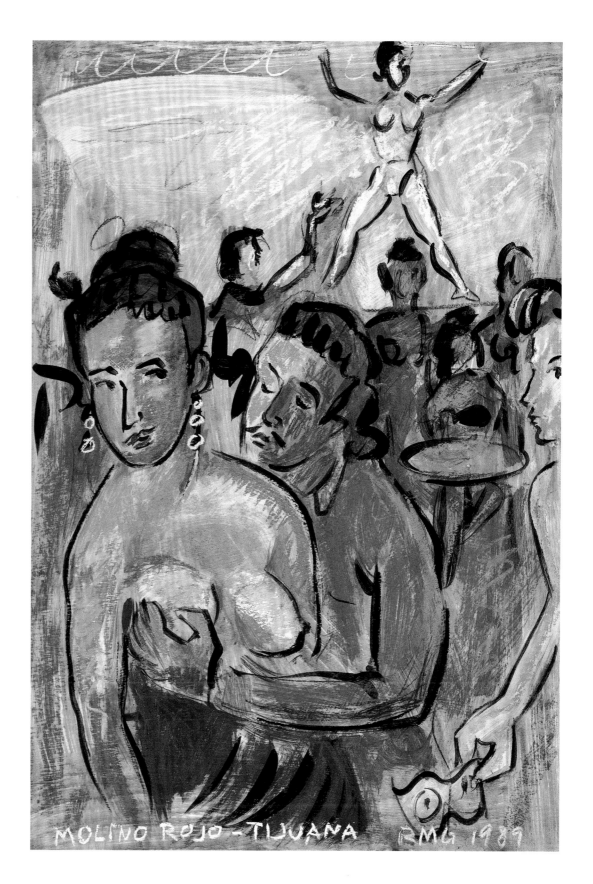

Raul Guerrero. *Molino Rojo*
(Moulin Rouge). 1989. Arches paper,
pastel, and gouache, 15 x 22".
Collection Cheech and Patti Marin

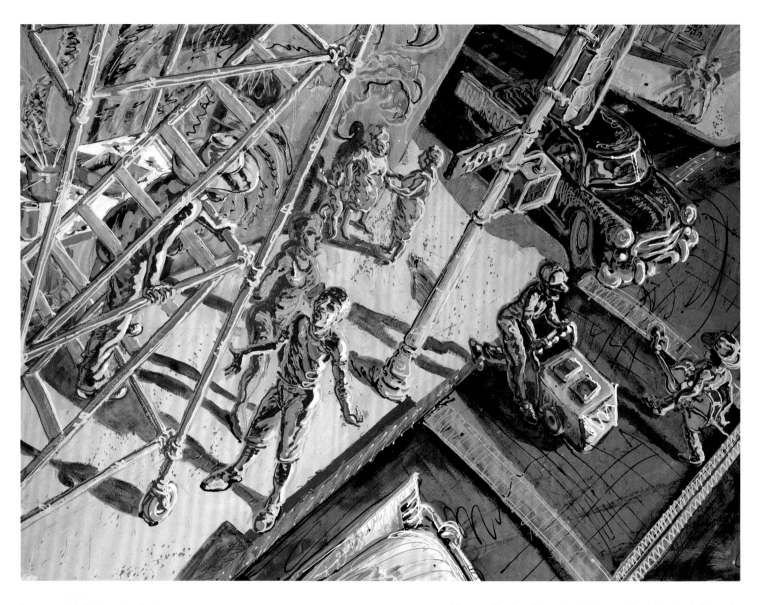

Wayne Alaniz Healy. *Beautiful
Downtown Boyle Heights*. 1993.
Acrylic on canvas, 94 x 69³/₄".
Collection Cheech and Patti Marin

*Norman Rockwell meets Jackson Pollock in East L.A. Healy
represents the perfect blend of these influences.*

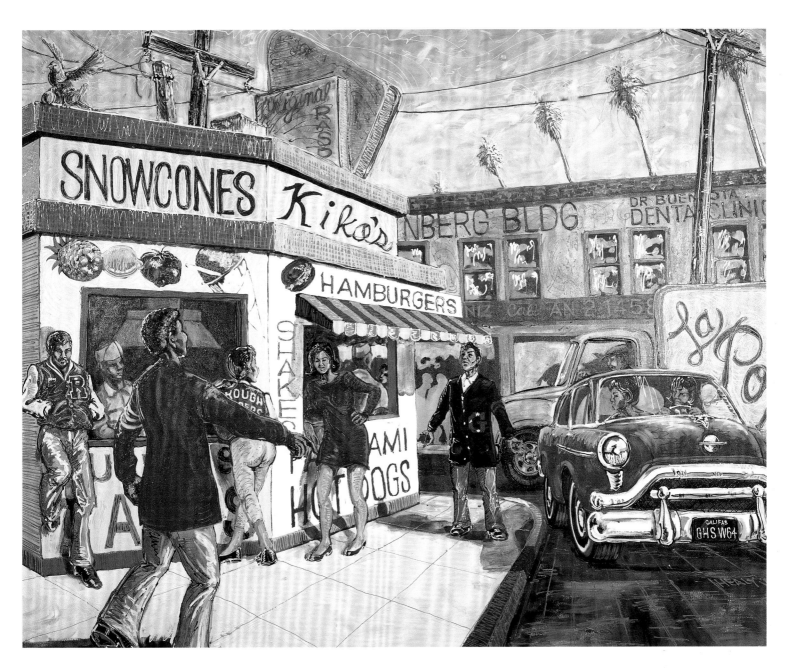

Wayne Alaniz Healy. *Pre-Game
Warmup*. 2001. Acrylic on canvas,
120 x 96". Collection Cheech and
Patti Marin

Wayne Alaniz Healy. *Una Tarde en Meoqui* (An Afternoon in Meoqui). 1991. Acrylic on canvas, 53½ x 53¾". Collection Cheech and Patti Marin

Una Tarde en Meoqui, detail

ESTER HERNÁNDEZ

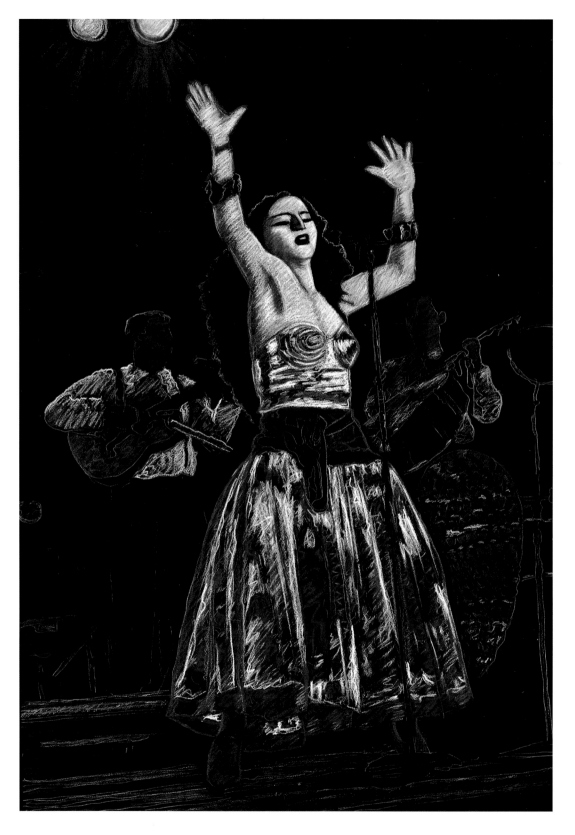

Ester Hernández. *Astrid Hadad in San Francisco*. 1994. Pastel on paper, 30 x 44". Collection Cheech and Patti Marin

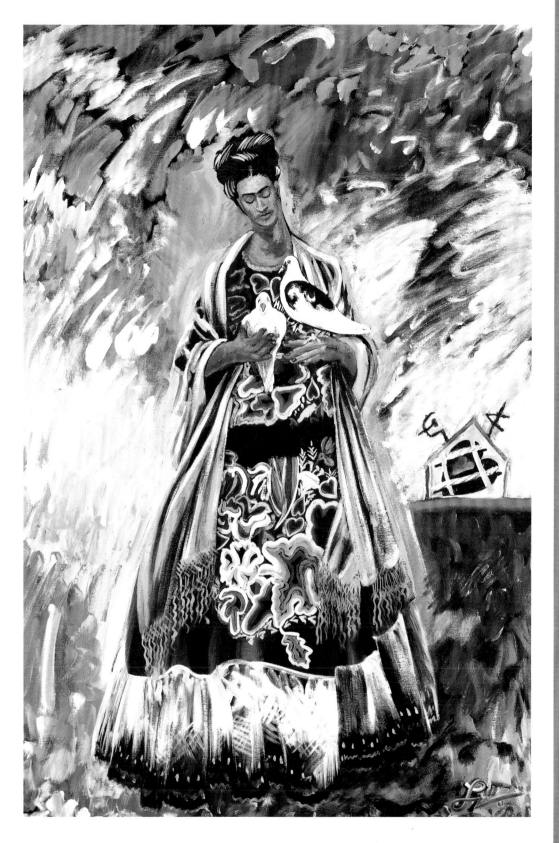

Leo Limón. *Frida and Palomas*. 2001.

Acrylic on canvas, 24 x 36".

Collection Cheech and Patti Marin

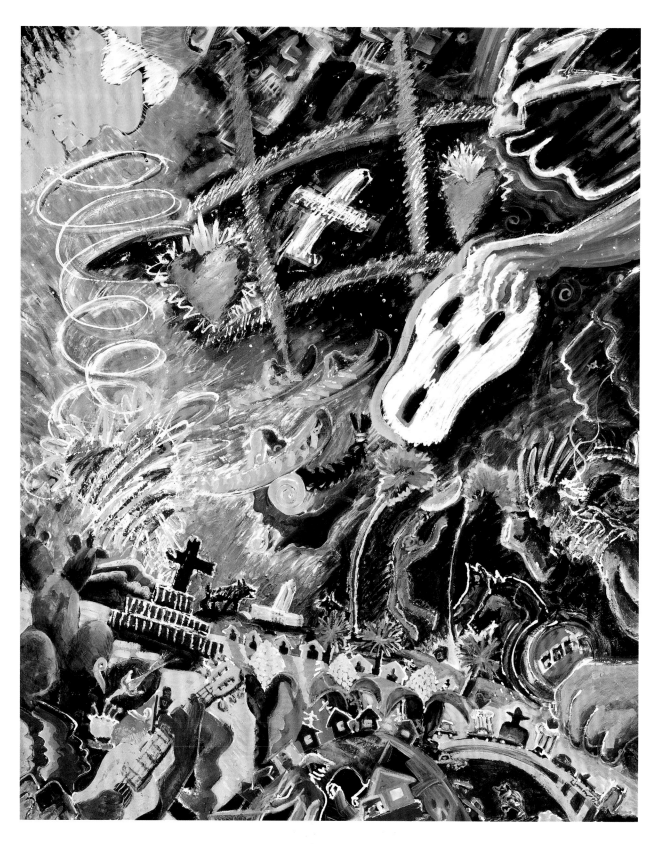

Leo Limón. *Un Poquito Sol*. 1991.
Acrylic on canvas, 47¼ x 59".
Collection Cheech and Patti Marin

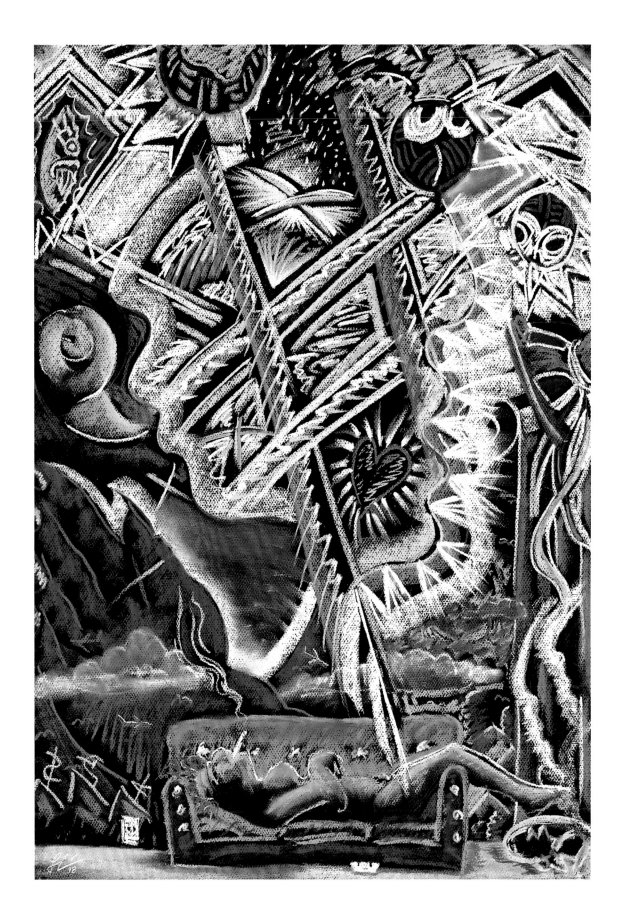

Leo Limón. *Mas Juegos* (More Games). 2000. Acrylic on canvas, 48 x 69¾". Collection Cheech and Patti Marin

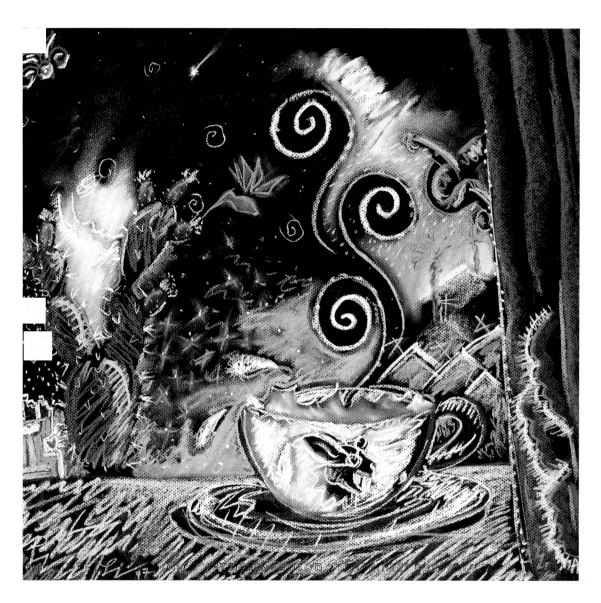

Leo Limón. *Cup of Tochtli.* 1997.
Pastel on paper, 20½ x 19½".
Collection Cheech and Patti Marin

Together with Carlos Almaraz, Leo Limón originated the swirling
Chicano iconography, whose symbols are rooted in ancient myth
and laden with personal meaning.

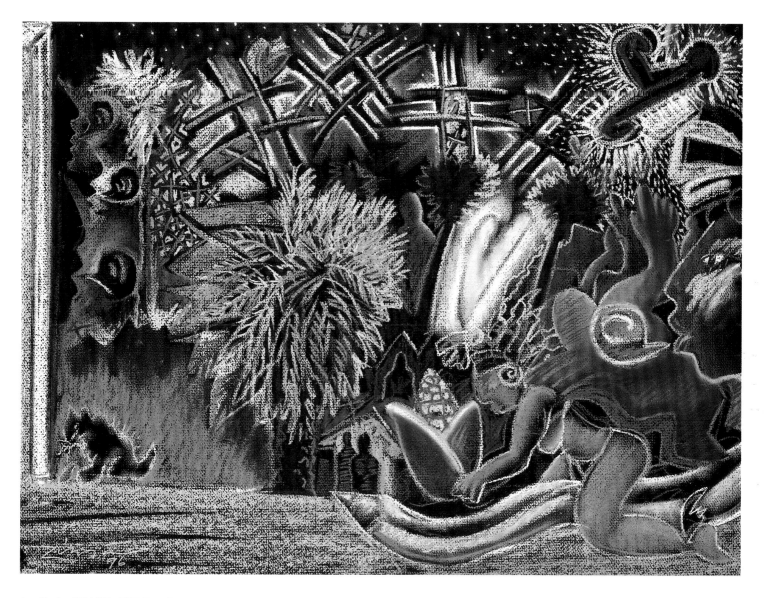

Leo Limón. *Wild Ride*. 1996. Pastel
on paper, 25¼ x 19". Collection
Cheech and Patti Marin

Leo Limón. *Ay! Dream of Chico's
Corazon* (Dream of Chico's Heart).
1992. Acrylic on canvas, 10½ x 13½".
Collection Cheech and Patti Marin

*Although not much bigger than a regular sheet of paper, this
painting makes a big statement.*

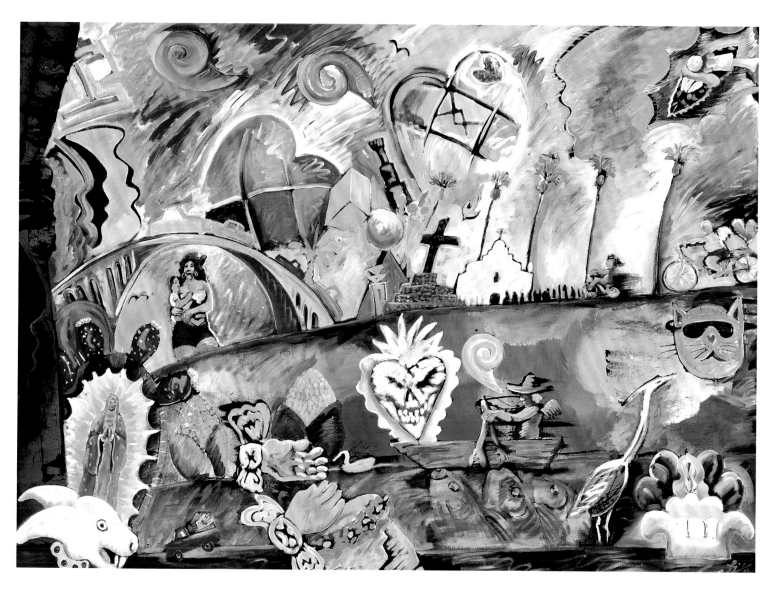

Leo Limón. *Los Muertos*. 1998.
Acrylic on canvas, 56 x 40".
Collection Cheech and Patti Marin

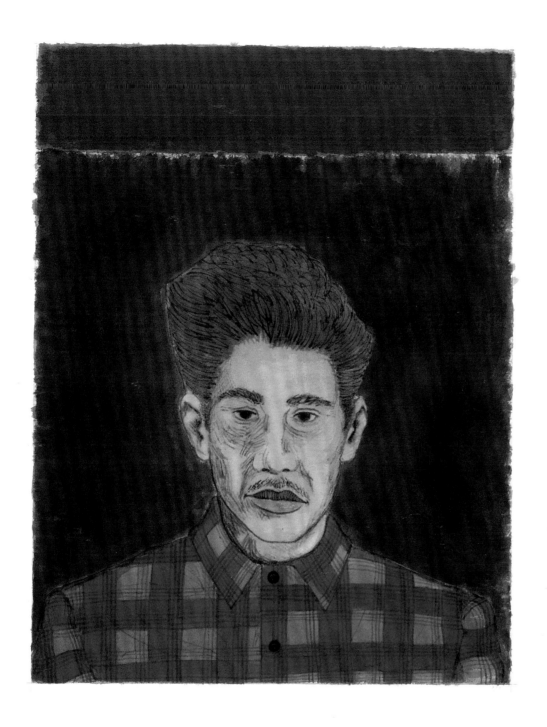

César Martínez. *Camisa de Cuadros*
(Shirt with Squares). 1990.
Watercolor on paper, 14 x 18".
Collection Cheech and Patti Marin

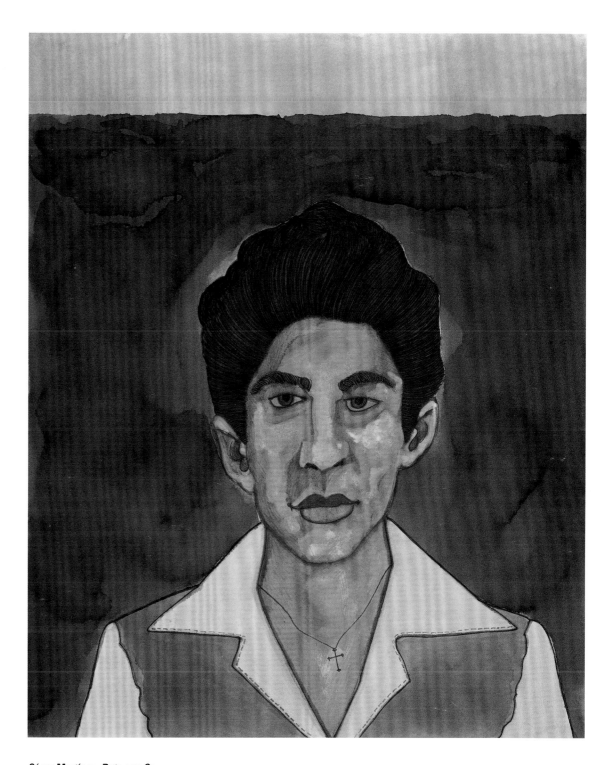

César Martínez. *Bato con Cruz*
(Dude with Cross). 1993. Watercolor
on paper, 17¾ x 21¾". Collection
Cheech and Patti Marin

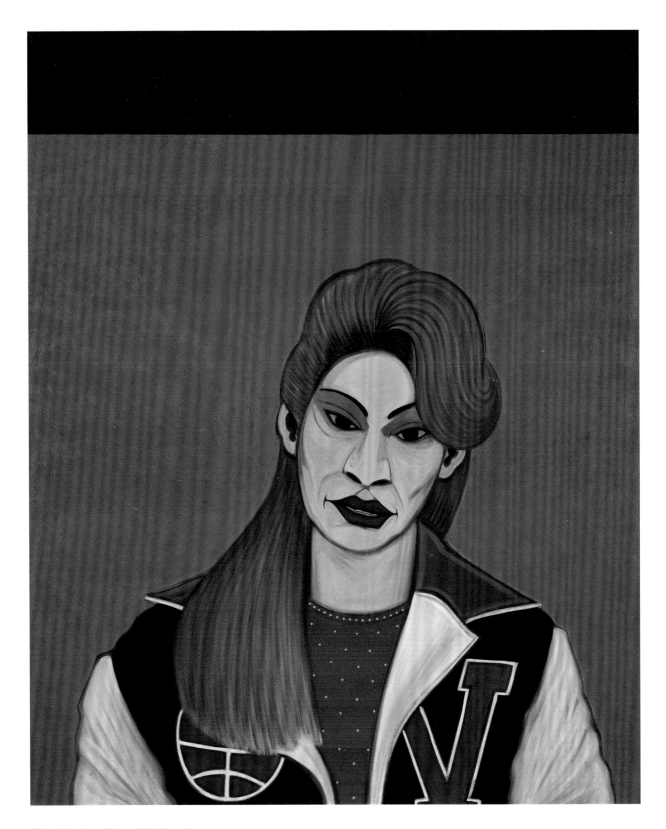

César Martínez. *Sylvia With Chago's
Letter Jacket.* 2000. Oil on canvas,
44 x 54". Collection Cheech and
Patti Marin

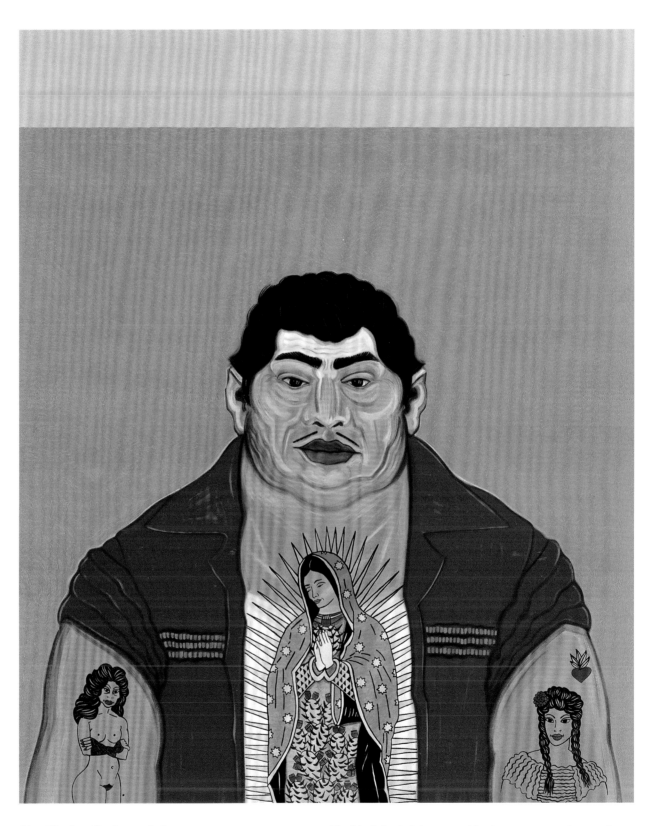

César Martínez. *Hombre que le Gustan las Mujeres* (The Man Who Loves Women). 2000. Oil on canvas, 44 x 54". Collection Cheech and Patti Marin

The Modigliani of the group. Martínez uses portraiture and Rothkoesque backgrounds to elevate local faces to hero status.

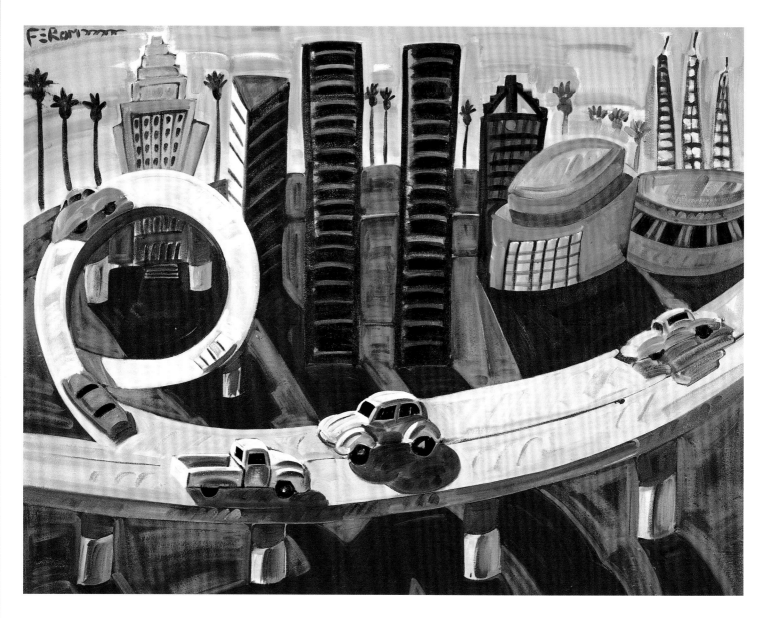

Frank Romero. *Downtown Streetscape*. 2000. Oil on canvas, 52 x 40". Collection Cheech and Patti Marin

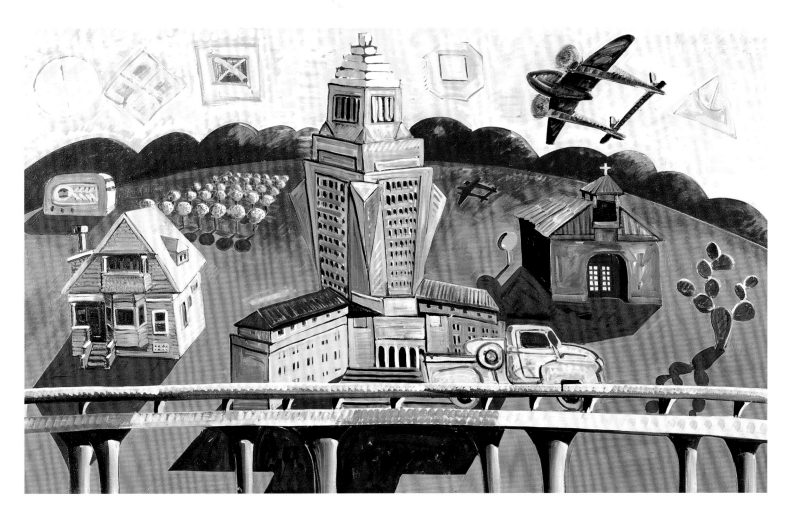

Frank Romero. *Pink Landscape*.
1984. Oil on canvas, 60¼ x 36".
Collection Cheech and Patti Marin

Frank Romero. *íMéjico, Mexico!*
(4 panels). 1984. Mixed media,
288 x 120" overall. Collection
Cheech and Patti Marin

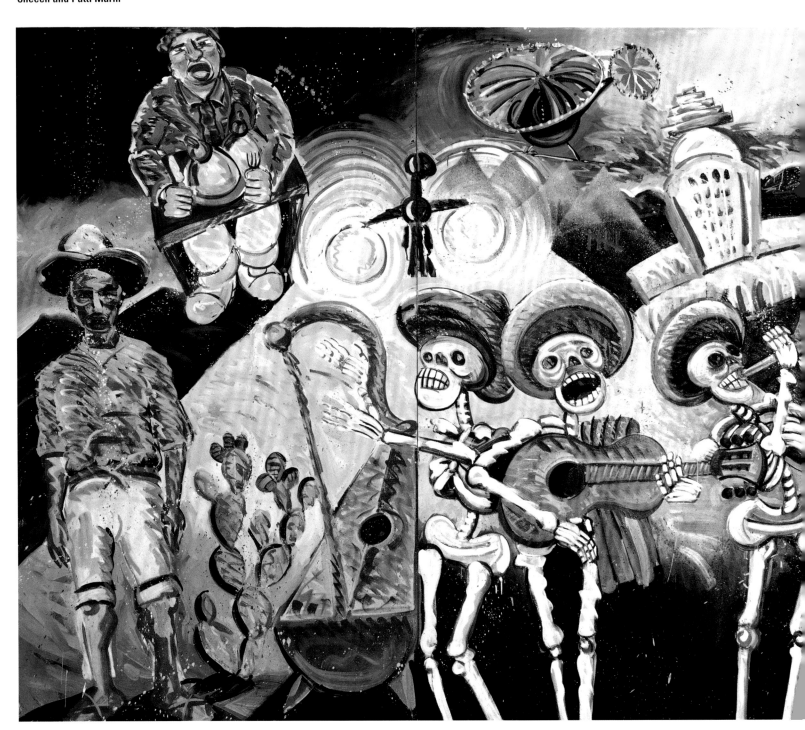

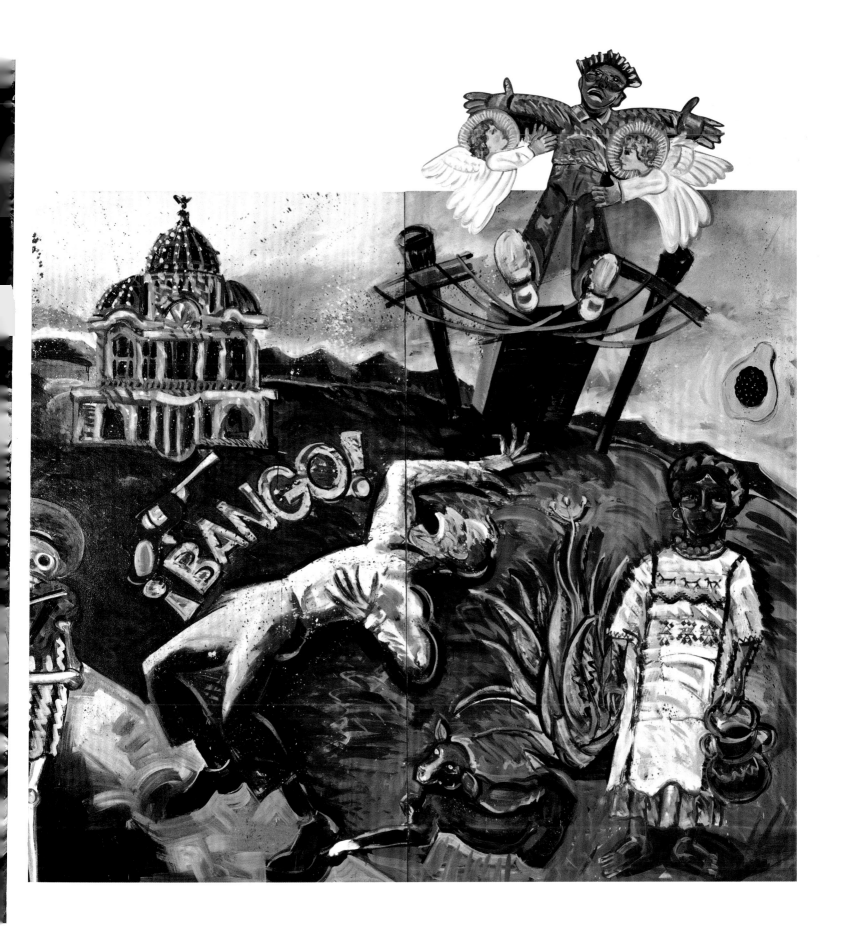

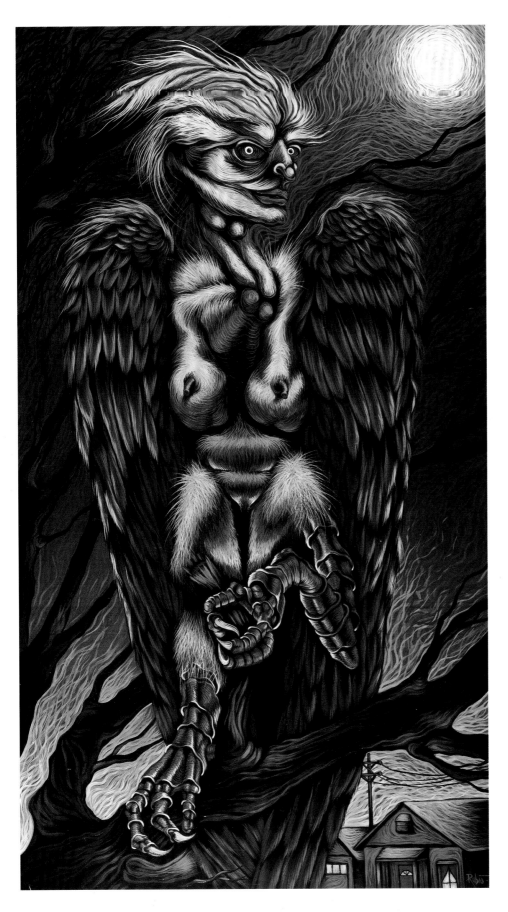

The owl woman is another Mexican bogey-man/bogeywoman. Seen with Romero's La Llorona, *page 113*, the two paintings contrast the old school (Romero) with the new school of Chicano art (Rubio).

Considering the size of the work and the amount of detail and texture, it's interesting to note that the artist only used the same-size paintbrush throughout.

Alex Rubio. *La Lechuza* (The Owl Woman). 2001. Oil on wood panel, 48 x 84". Collection Cheech and Patti Marin

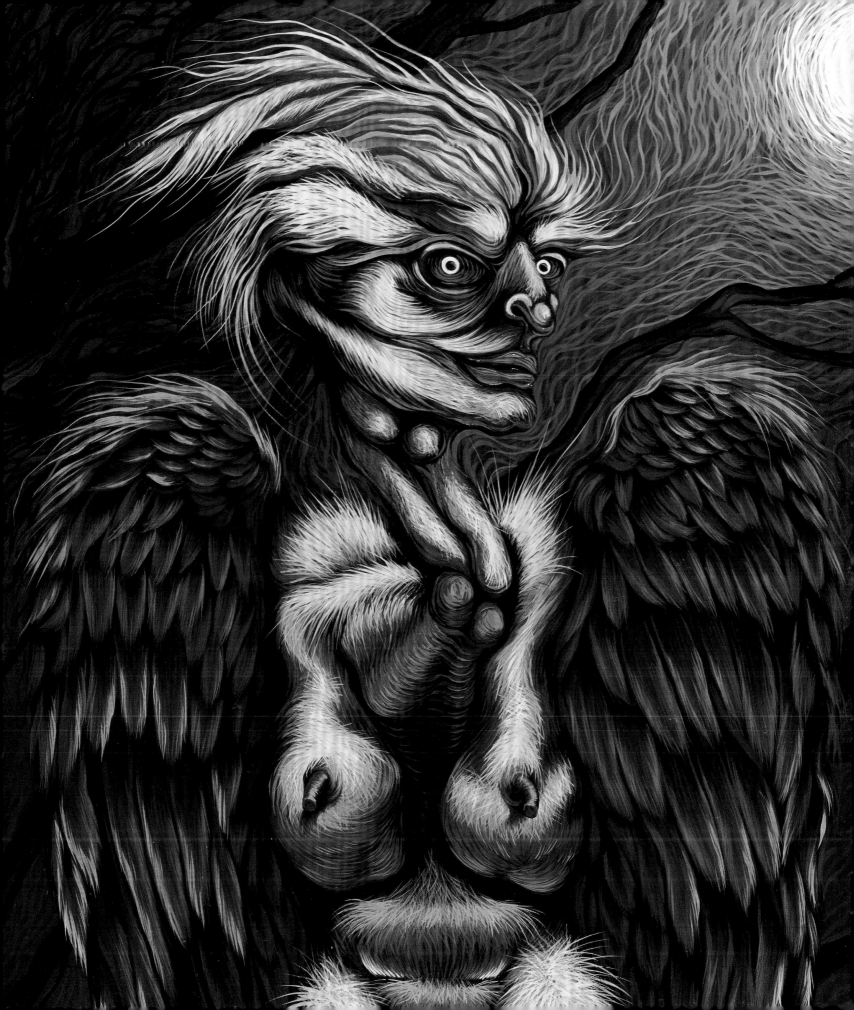

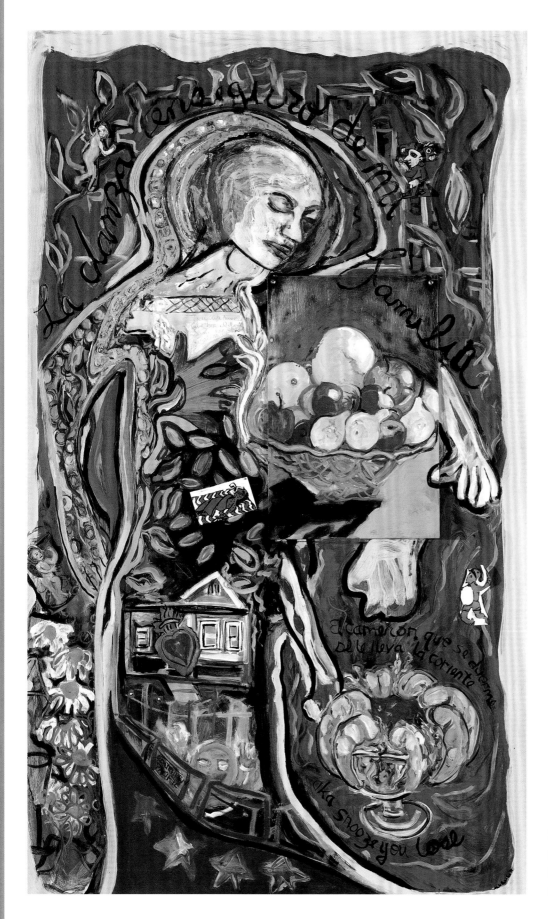

Marta Sánchez. *La Danza* (The Dance). 1994. Oil enamel on metal, 35½ x 59½". Collection Cheech and Patti Marin

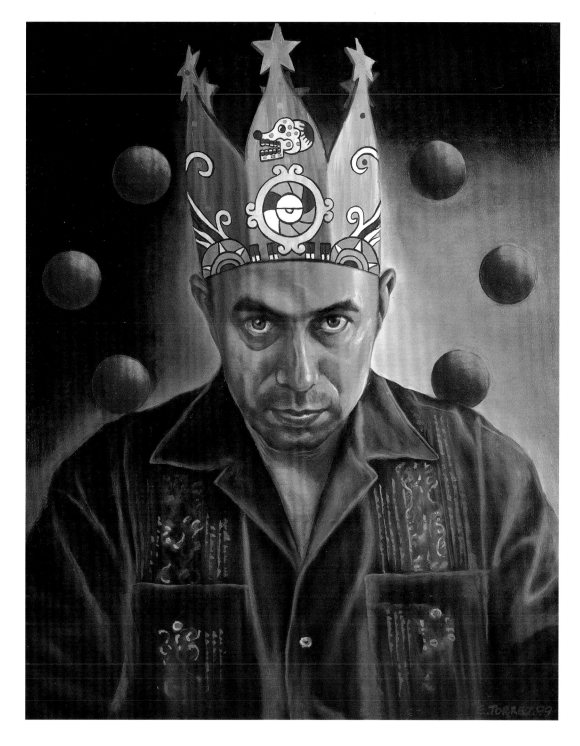

Eloy Torrez. *Herbert Siguenza*. 2000.
Oil on canvas, 15 x 19". Collection
Cheech and Patti Marin

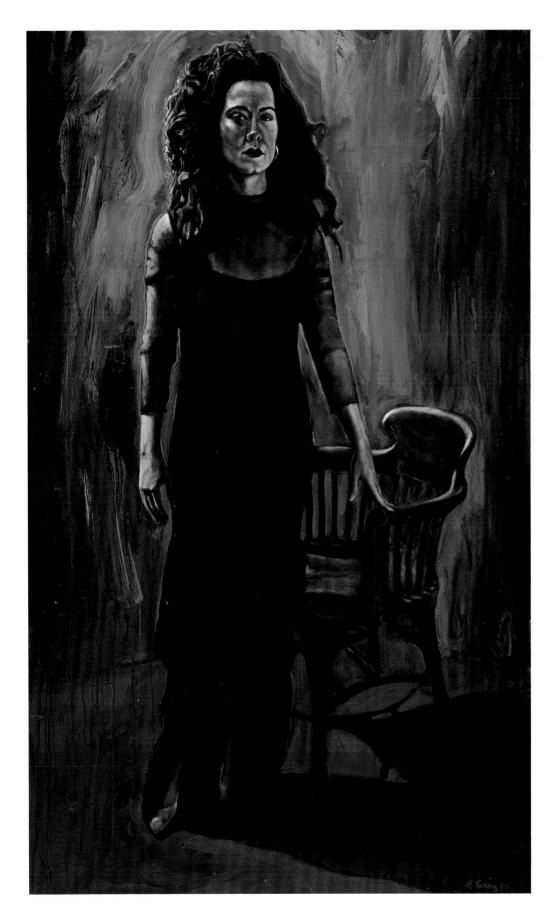

Eloy Torrez. *The Red Floor*. 1990.
Acrylic on paper, 35 x 55".
Collection Cheech and Patti Marin

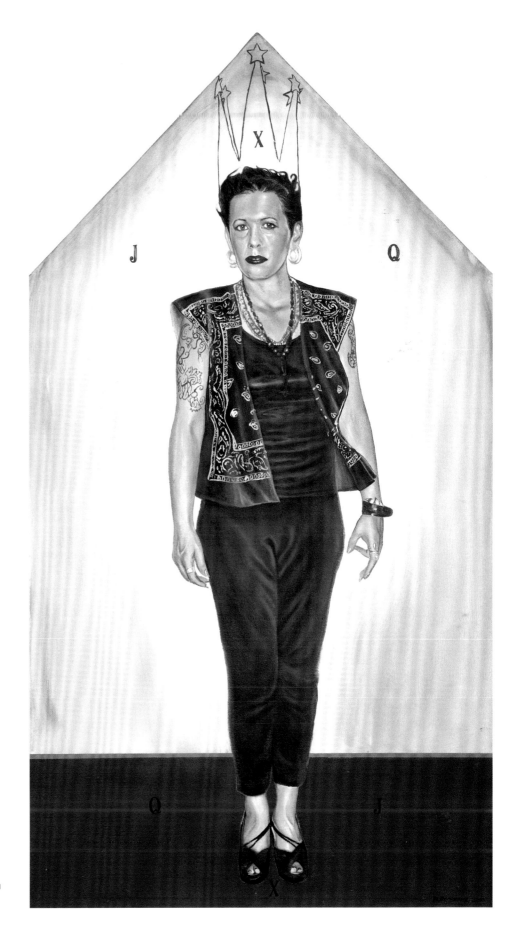

Eloy Torrez. *Diane Gamboa*. 2000.
Oil on canvas, 18¼ x 33". Collection
Cheech and Patti Marin

Jesse Treviño. *Guadalupe y
Calaveras.* 1976. Acrylic on canvas,
66 x 48". Collection Terry Vasquez

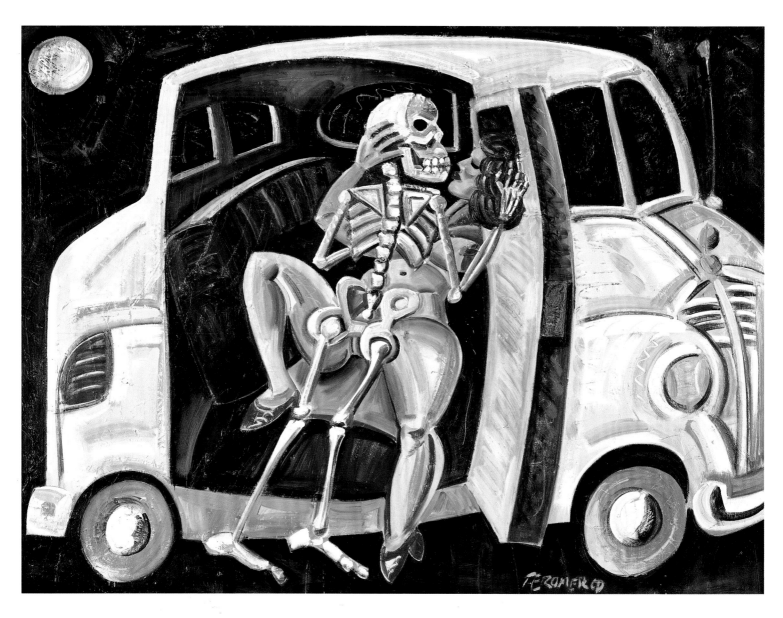

Frank Romero. *Back Seat Dodge,
Homage to Keinholtz*. 1991. Oil on
canvas, 47½ x 35½". Collection
Cheech and Patti Marin

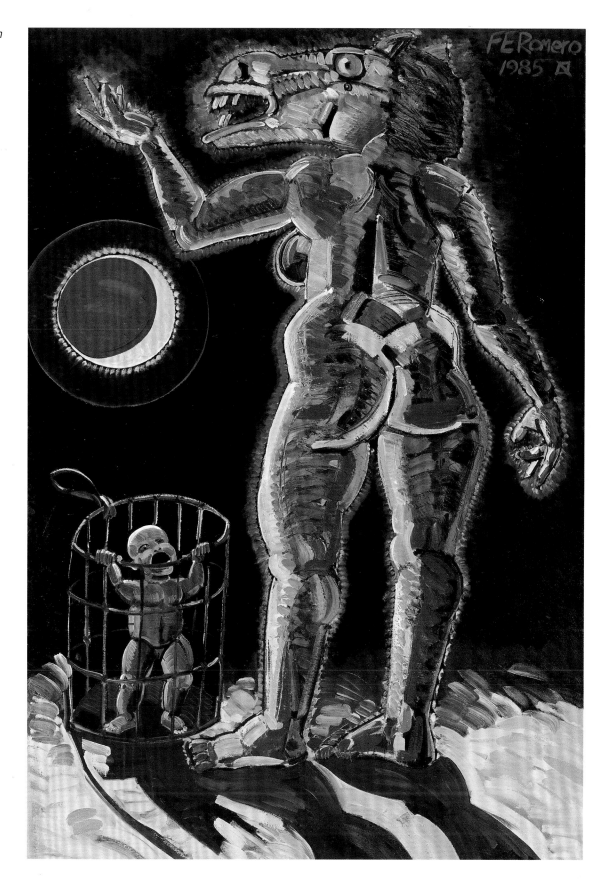

The Mexican myth of the woman who killed her children and wanders the landscape looking for strays.

Frank Romero. *La Llorona* (The Weeping Women). **1985. Oil on canvas, 50 x 72". Collection Cheech and Patti Marin**

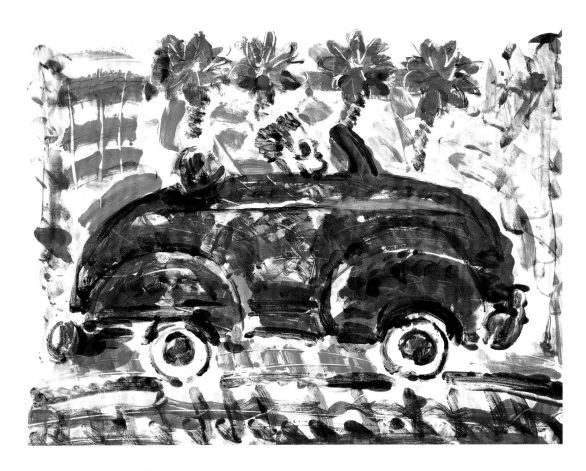

Frank Romero. *Cruising #1*. 1988.
Monoprint, 29½ x 22". Collection
Cheech and Patti Marin

Frank Romero. *Johanna*. 1991. Pastel
on paper, 40 x 22". Collection
Cheech and Patti Marin

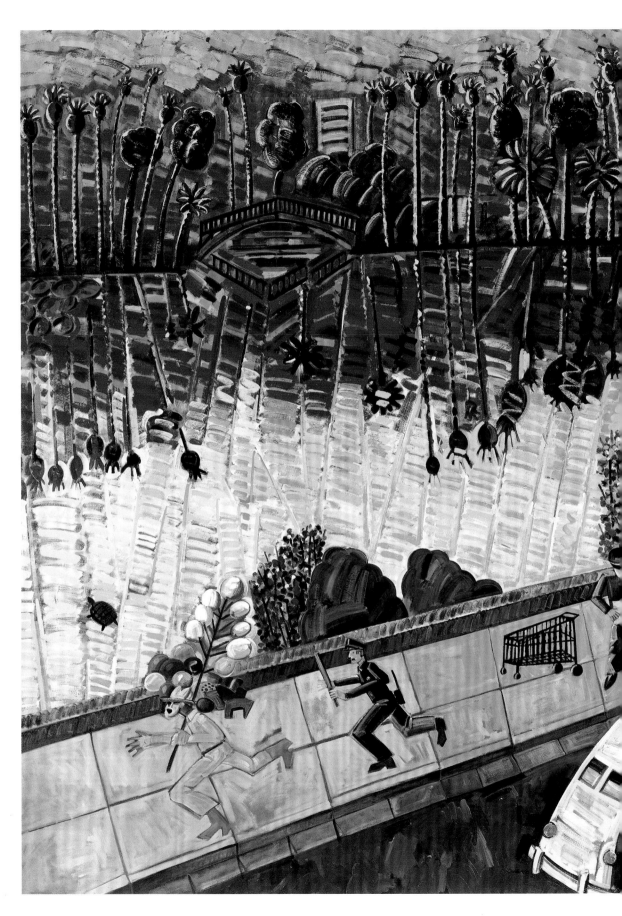

Frank Romero. *The Arrest of the Paleteros* (diptych). 1996. Oil on canvas, 144 x 96" overall. Collection Cheech and Patti Marin

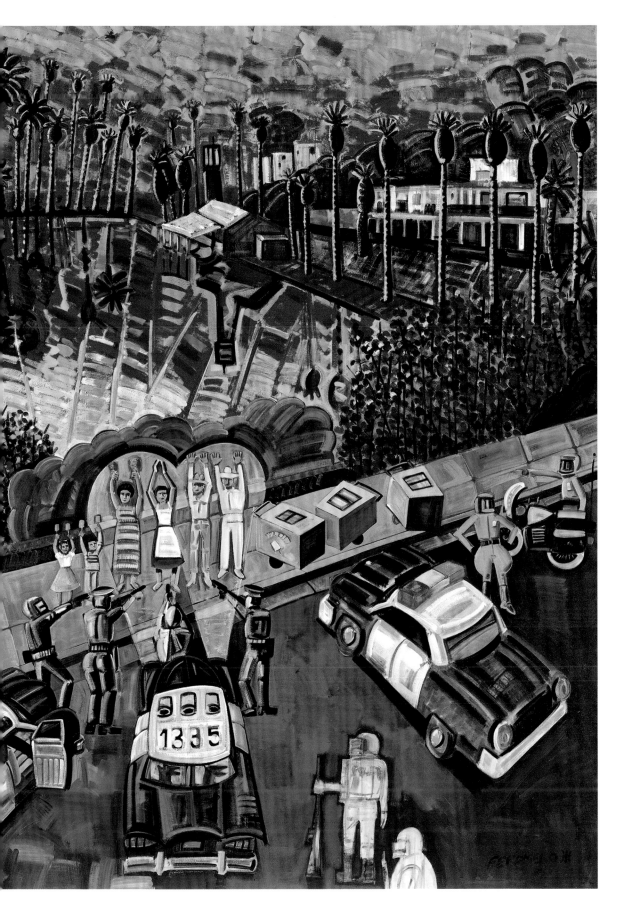

Paleteros, *or ice cream men,*
were the most innocent and
representative of transplanted
Mexican culture in Los Angeles.
The fact that they were frequently
arrested for not having vendor
permits attests to the kind of
ludicrous racial prejudice that
exists beside the other truly
serious dangers of Echo Park.

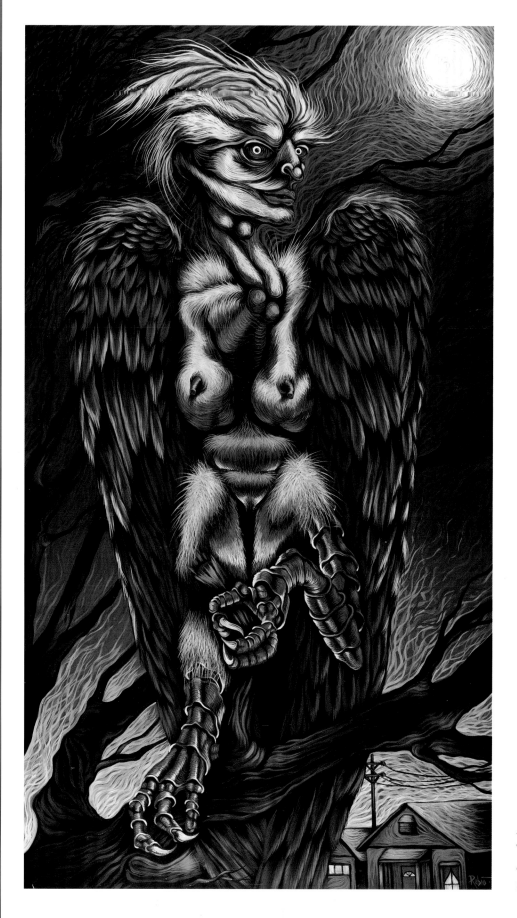

The owl woman is another Mexican bogey-man/bogeywoman. Seen with Romero's La Llorona, *page 113*, the two paintings contrast the old school (Romero) with the new school of Chicano art (Rubio).

Considering the size of the work and the amount of detail and texture, it's interesting to note that the artist only used the same-size paintbrush throughout.

Alex Rubio. *La Lechuza* (The Owl Woman). 2001. Oil on wood panel, 48 x 84". Collection Cheech and Patti Marin

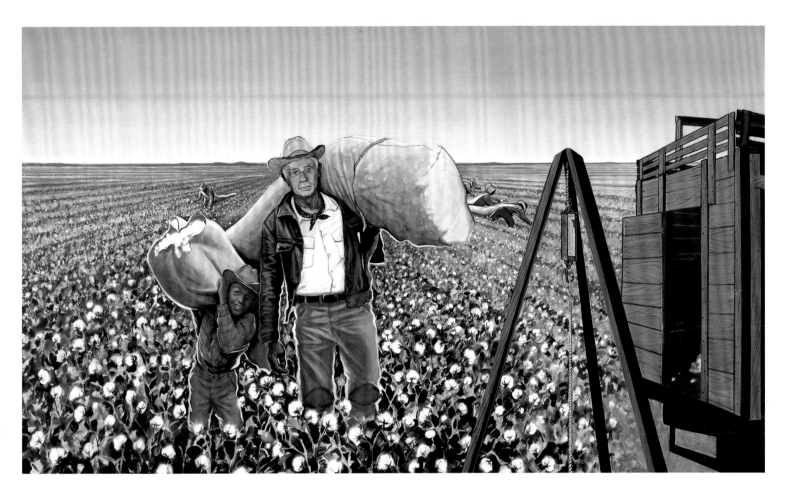

Jesse Treviño. *Los Piscadores*. 1985.
Acrylic on canvas, 82 x 48".
Collection Judge Juan F. Vasquez

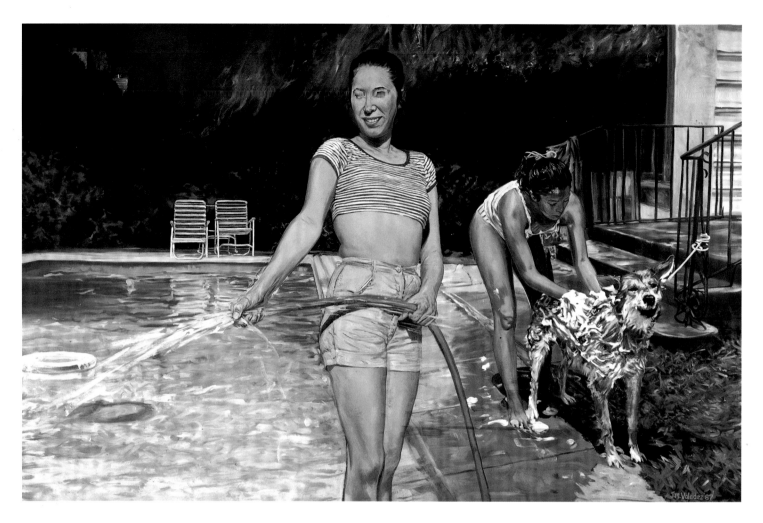

John Valadez. *Pool Party*. 1986.
Oil on canvas, 107 x 69". Collection
Cheech and Patti Marin

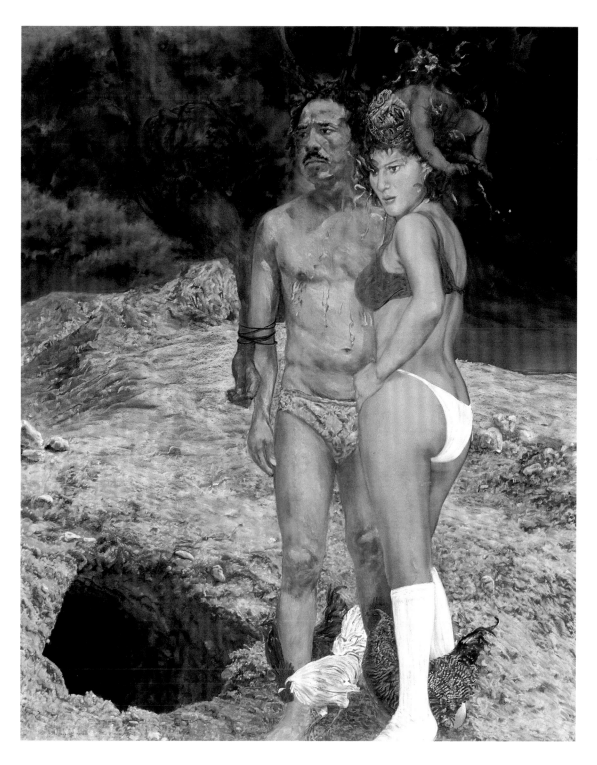

John Valadez. *Revelations*. 1991.
Pastel on paper, 50½ x 61".
Collection Cheech and Patti Marin

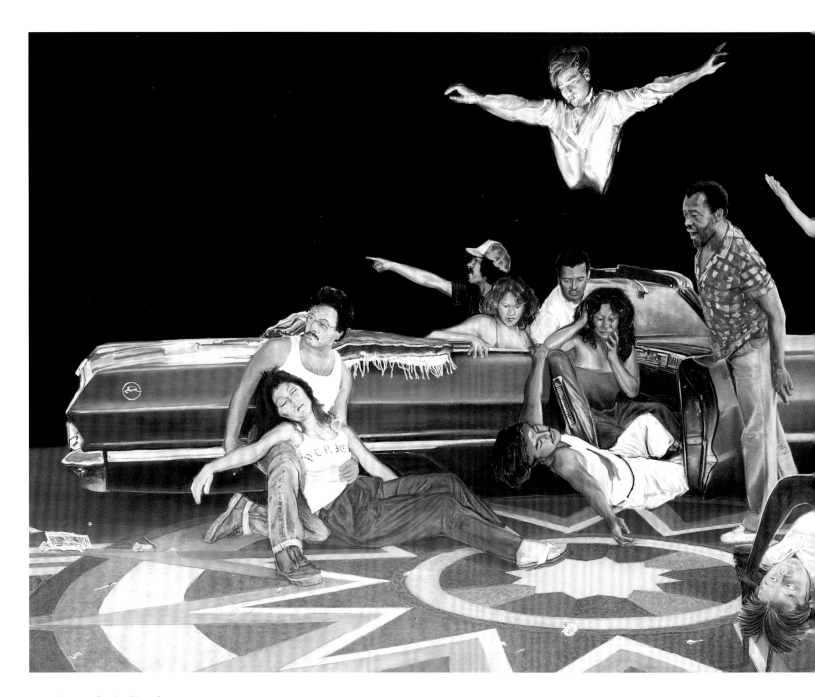

John Valadez. *Getting Them Out of the Car*. 1984. Pastel on paper, 100 x 37½". Collection Cheech and Patti Marin

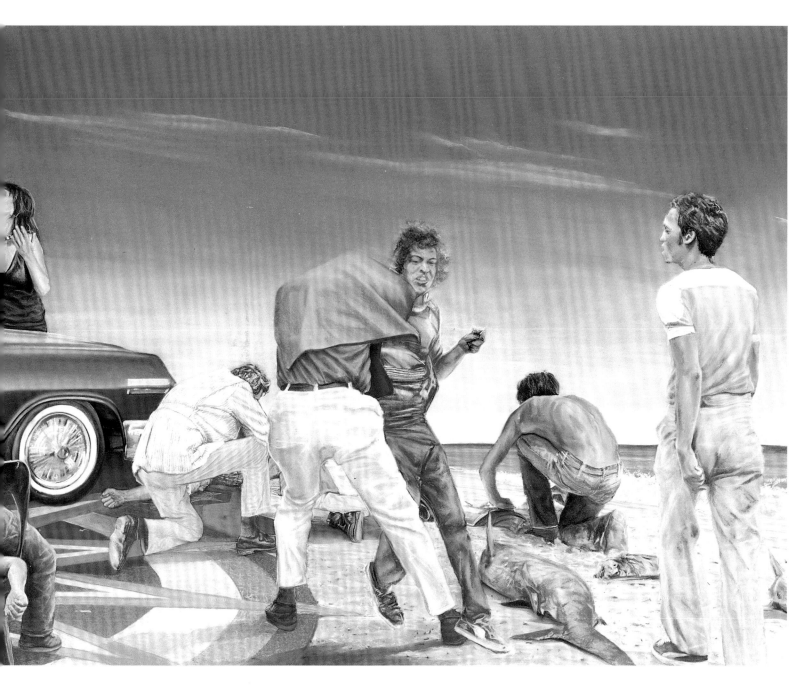

Valadez excels as a master Photorealist, which is even more difficult to achieve when working in pastel. Ginger Rogers once remarked that she did everything that Fred Astaire did, only backwards and in high heels.

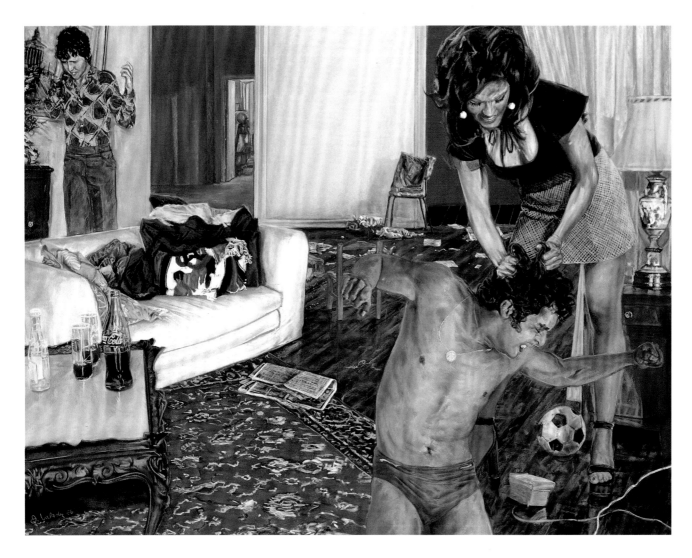

John Valadez. *Tony and Edie*. 1986.
Pastel on paper, 50 x 38". Collection
Robert Berman

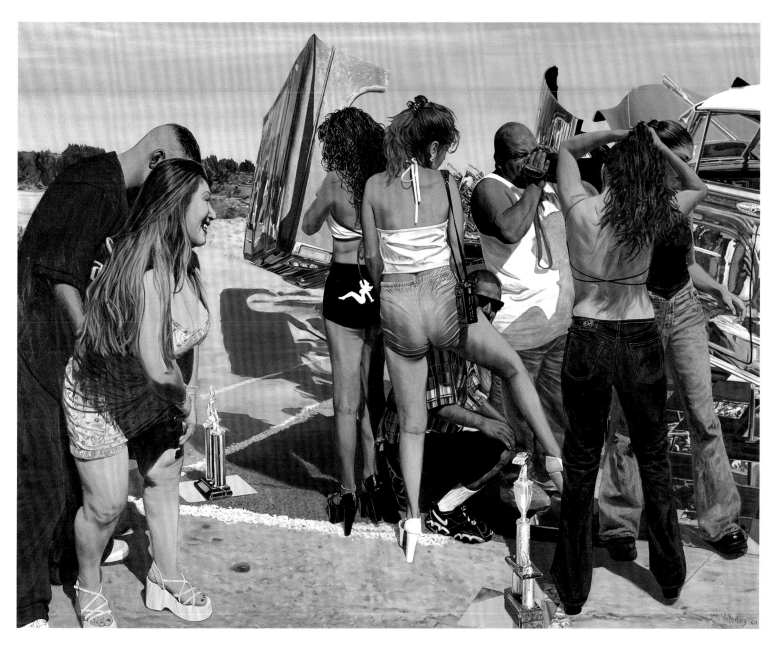

John Valadez. *Car Show*. 2001.
Oil on canvas, 96¼ x 76". Collection
Dennis Hopper

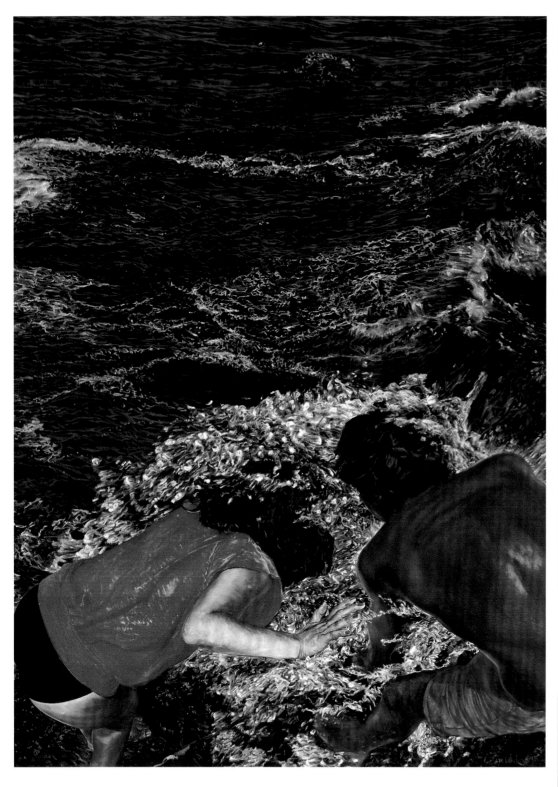
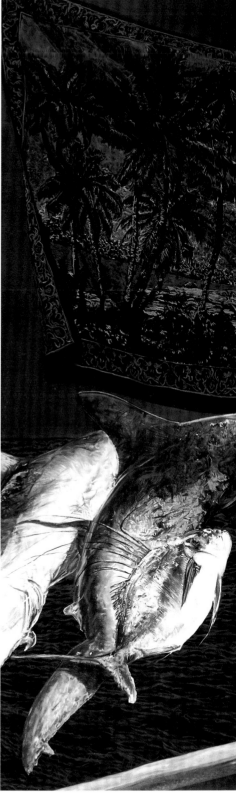

John Valadez. *Beto's Vacation*
(Water, Land, Fire) (triptych). 1985.
Pastel on paper, 50 x 68", 50 x 72",
50 x 68". Collection Dennis Hopper

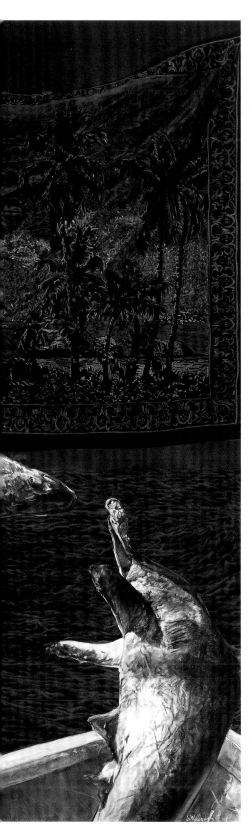

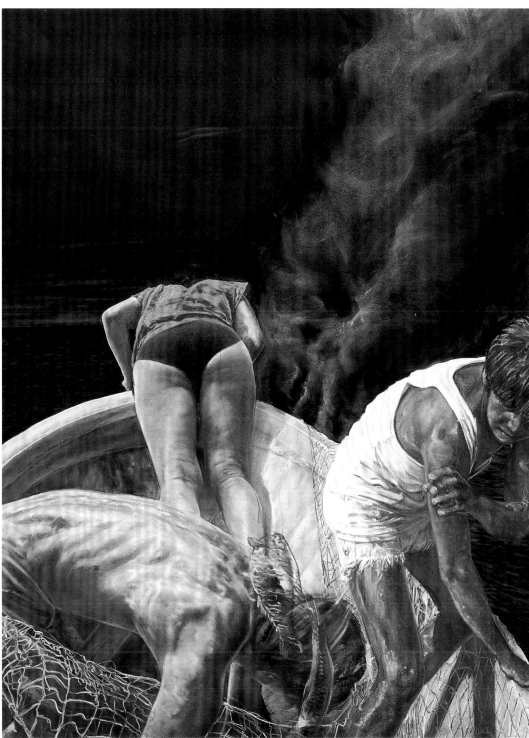

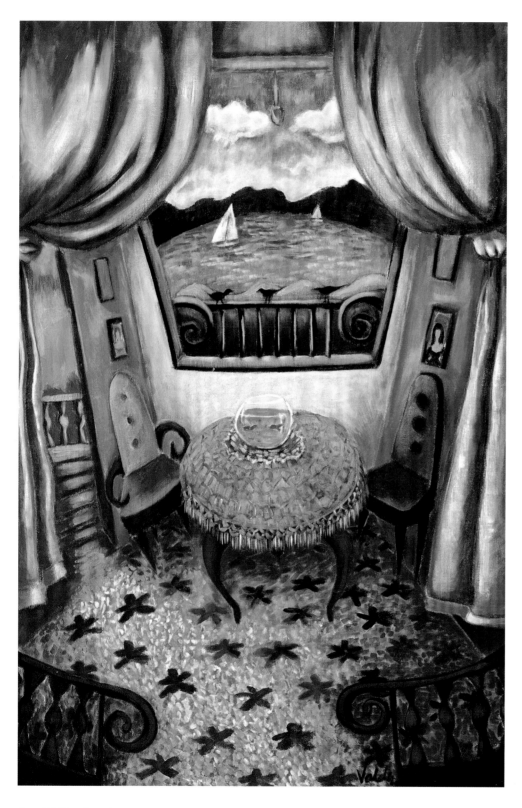

Patssi Valdez. *Saturday*. 1997.
Acrylic on canvas, 24 x 36".
Collection Cheech and Patti Marin

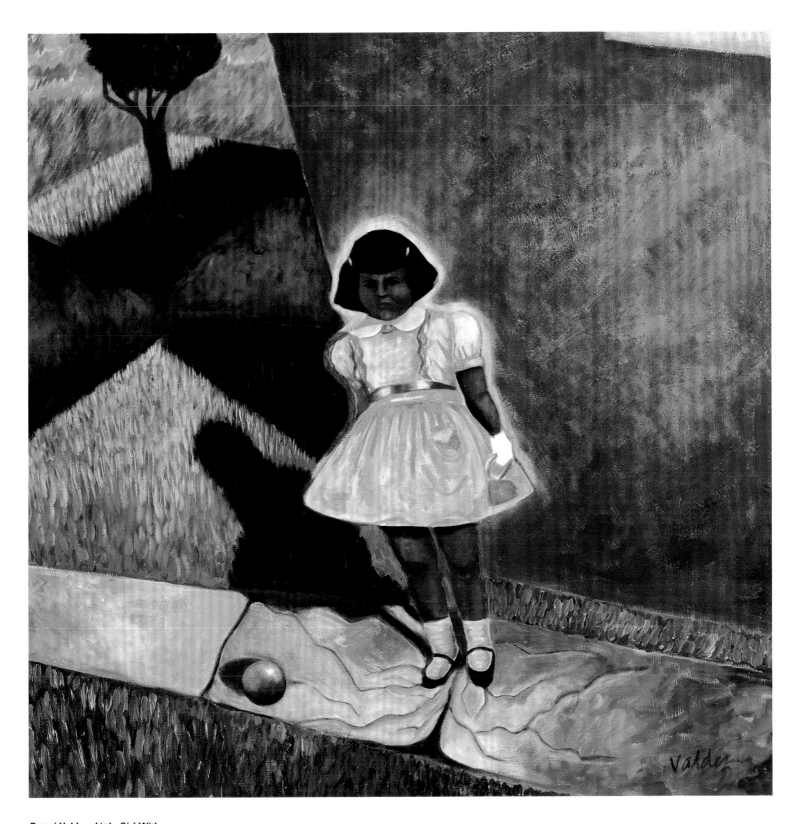

Patssi Valdez. *Little Girl With
Yellow Dress*. 1995. Acrylic on
canvas, 36 x 36". Collection Cheech
and Patti Marin

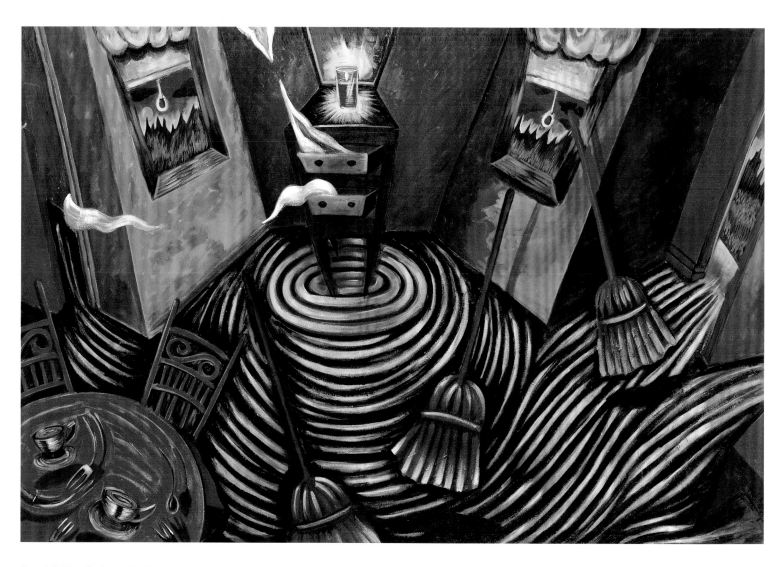

Patssi Valdez. *Room on the Verge.*
1993. Acrylic on canvas, 72 x 48".
Collection Cheech and Patti Marin

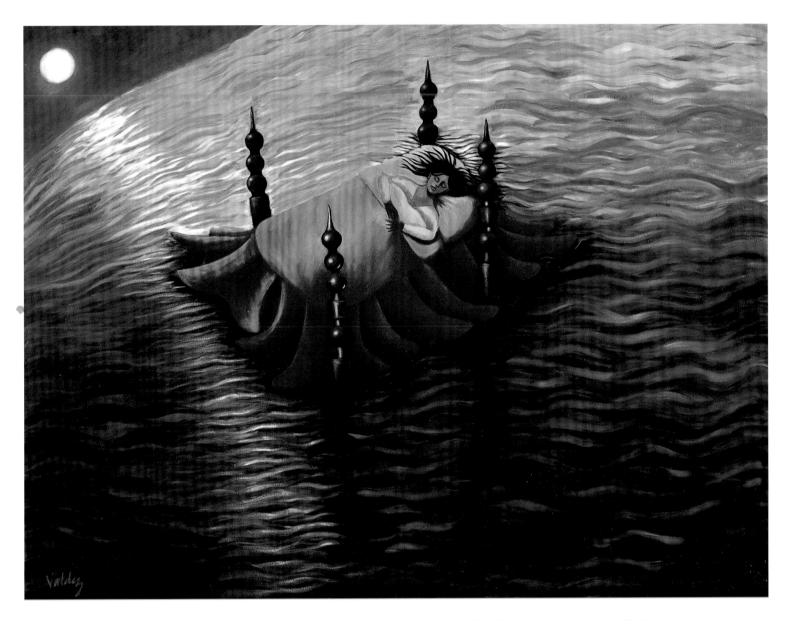

Patssi Valdez. *The Dream*. 2000.
Acrylic on canvas, 96 x 72".
Collection the artist

Patssi Valdez, whose paintings glow like holy cards, takes you on an emotional journey while never leaving her room.

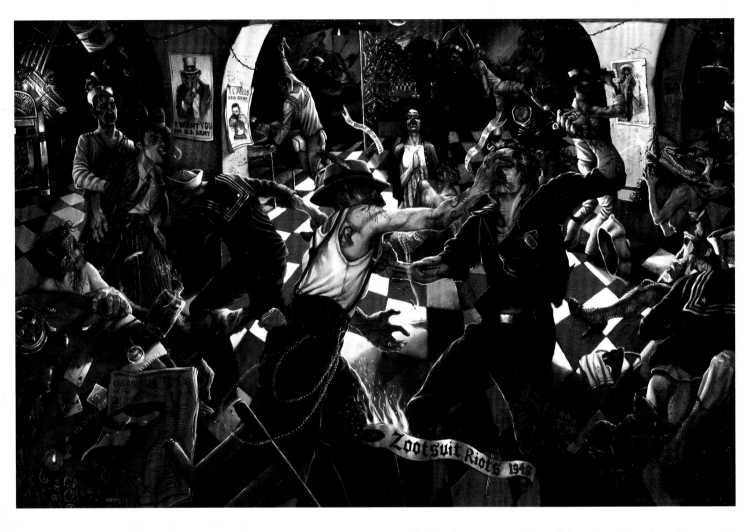

Vincent Valdez. *Kill the Pachuco Bastard!*. 2001. Oil on canvas, 72 x 48". Collection Cheech and Patti Marin

Valdez, the youngest painter of the artists shown here, is a recent graduate of the Rhode Island School of Design. It speaks well of the concept of a "Chicano School of Painting" when its youngest member chooses to depict one of the seminal events of Chicano history, the zoot suit riots of the 1940s.

Kill the Pachuco Bastard!, detail

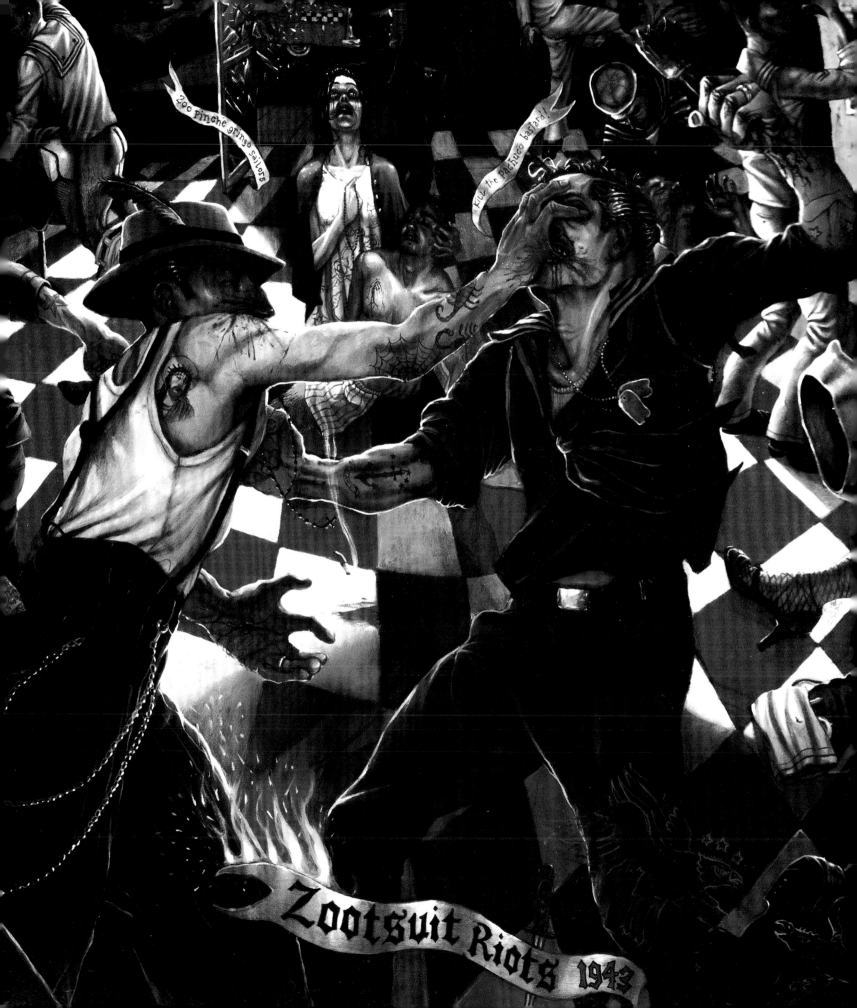

George Yepes. *La Pistola y el
Corazon* (The Pistol and the Heart).
1989. Serigraph, 34 x 42". Collection
Cheech and Patti Marin

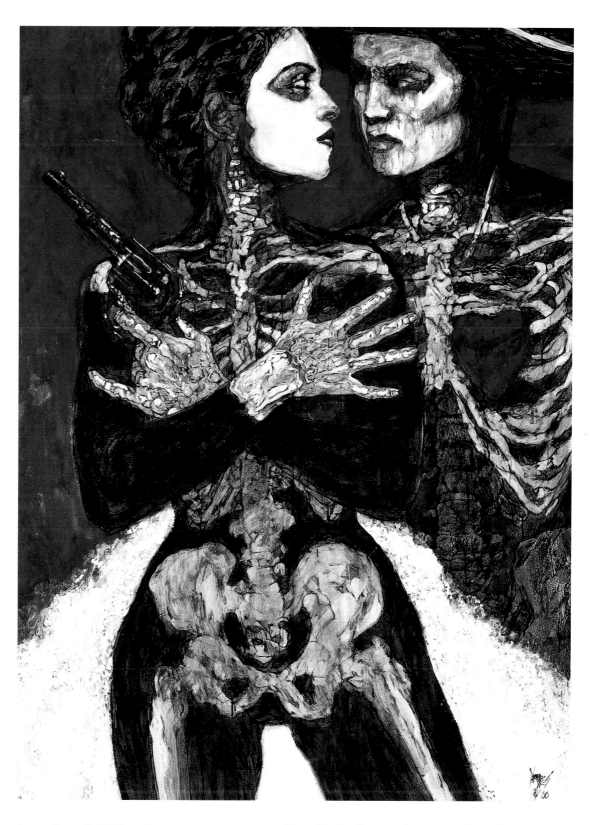

George Yepes. *La Pistola y el Corazon* (The Pistol and the Heart). 2000. Oil on canvas, 60 x 81½". Collection Cheech and Patti Marin

The original painting, which was much smaller, was owned by Sean Penn. A few years back, it was lost in a trailer fire. Yepes painted this larger one especially for the exhibition.

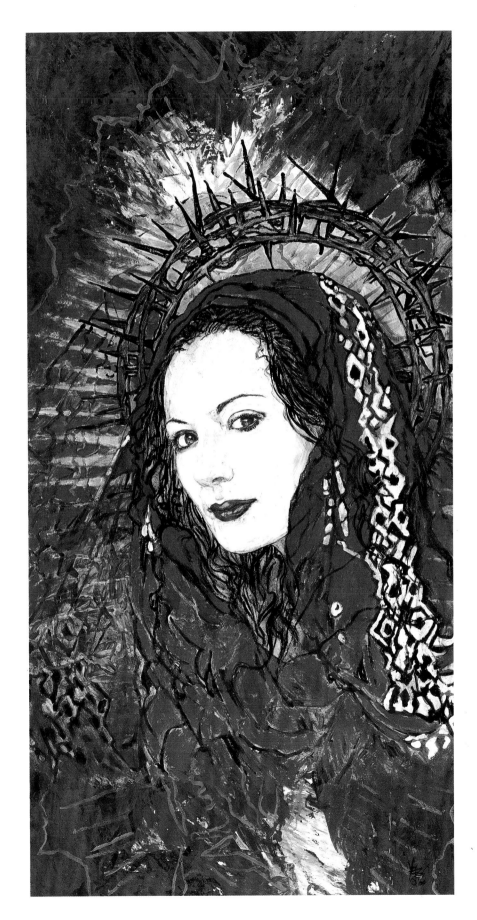

George Yepes. *La Magdalena*. 2000.
Oil on canvas, 41 x 80". Collection
Cheech and Patti Marin

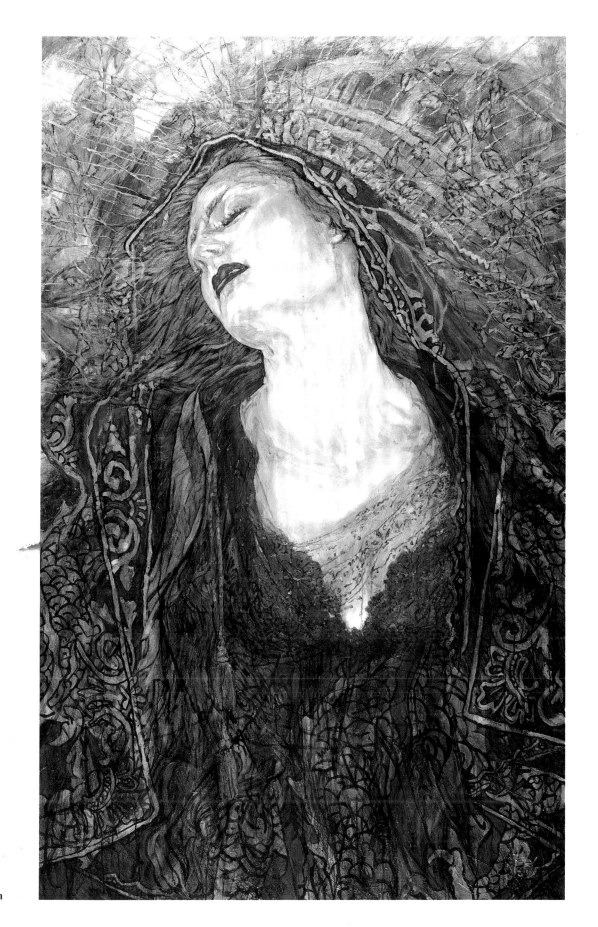

George Yepes. *Axis Bold as Love.*
2001. Acrylic on canvas, 60 x 96".
Collection Cheech and Patti Marin

Patssi Valdez

Patssi Valdez began her artistic career in the 1970s as a Garfield High School student in East Los Angeles. She was the only female among the seminal, four-member Chicano art group Asco. Asco expanded the definition of Chicano art beyond murals and posters by experimenting with a range of art forms, including street performance, photographic montage, pageantry, and conceptual art. She has also done set design work on films.

In January 2001, "Patssi Valdez: A Precarious Comfort" opened at The Mexican Museum in San Francisco. In March, Valdez was one of only three Los Angeles artists awarded a $25,000 Durfee Artist Fellowship based on past artistic achievement and future promise.

Vincent Valdez

Vincent Valdez was born and raised in San Antonio, Texas, and is the youngest artist represented in the Chicano exhibition. His first artistic influences came from the canvases of his late great-grandfather, an artist from Spain. Valdez began drawing at the age of three; as early as kindergarten, he realized his artistic abilities differed from others. While participating in a mural project at San Antonio's Esperanza Peace and Justice Center when he was only ten years old, Valdez decided art would be his career. He worked with his mentor, artist/muralist Alex Rubio, on murals around the Alamo City, eventually painting on his own.

Upon graduating from Burbank High School, Valdez received a full scholarship to the International Fine Arts College in Miami, Florida. After one year, he accepted a full scholarship and transferred to the Rhode Island School of Design in Providence, Rhode Island, where he completed his Bachelor of Fine Arts degree in illustration. Valdez exhibits and works on commissioned pieces and teaches art to middle school students in San Antonio.

George Yepes

Called "the City's Preeminent Bad Ass Muralist" (*L.A. New Times,* June 2000), George Yepes was also named a "treasure of Los Angles" in 1997 by Mayor Richard Riordan. Born in Tijuana, raised in East Los Angeles, and formed by a street life of poverty and gang violence, Yepes calls on classical master works from Velásquez to Titian for inspiration. This self-taught artist has a distinctly refined renaissance bent to his work, although religious iconography and erotica are also prevalent. His paintings and murals combine the bravado of Chicano street sense with classical standards. His album cover for Los Lobos, titled *La Pistola y el Corazon,* has won numerous awards and is in many museum collections. The twenty-eight public murals he has done in Los Angeles are recognized landmarks, as are the twenty-one murals painted by students in his Academia de Arte Yepes.

List of Plates

Carlos Almaraz. *California Natives*. 1988. Oil on canvas, 84 x 60". Collection Cheech and Patti Marin

Carlos Almaraz. *Creatures of the Earth*. 1984. Oil on canvas, 35 x 43". Collection Cheech and Patti Marin

Carlos Almaraz. *Early Hawaiians* (triptych). 1983. Oil on canvas, 163 x 72" overall. Collection Los Angeles County Museum of Art. Gift of William H. Bigelow, III. M.91.288 a-c. © 2002 The Carlos Almaraz Estate

Carlos Almaraz. *Flipover*. 1983. Oil on canvas, 72 x 36". Collection Mrs. Liz Michaels Hearne and John Hearne

Carlos Almaraz. *Pyramids* (triptych). 1984. Oil on canvas, 144 x 96" overall. Collection Cheech and Patti Marin

Carlos Almaraz. *Southwest Song*. 1988. Serigraph, 48 x 34½". Collection Cheech and Patti Marin

Carlos Almaraz. *Sunset Crash*. 1982. Oil on canvas, 43 x 35". Collection Cheech and Patti Marin

Carlos Almaraz. *The Two Chairs*. 1986. Oil on canvas, 66 x 79½". Collection Cheech and Patti Marin

Carlos Almaraz. *West Coast Crash*. 1982. Oil on canvas, 54 x 18". Collection Elsa Flores Almaraz

Chaz Bojórquez. *Chino Latino*. 2000. Acrylic on canvas, 72 x 60". Collection Cheech and Patti Marin

Chaz Bojórquez. *Words That Cut*. 1991. Acrylic on canvas, 92 x 65". Collection Nicolas Cage

David Botello. *Alone and Together Under the Freeway*. 1992. Acrylic on canvas, 34 x 25". Collection Cheech and Patti Marin

David Botello. *Wedding Photos-Hollenbeck Park*. 1990. Oil on canvas, 47½ x 35¼". Collection Cheech and Patti Marin

Mel Casas. *Humanscape 62 (Brownies of the Southwest)*. 1970. Oil on canvas, 97 x 73". Collection the artist

Mel Casas. *Humanscape 63 (Show of Hands)*. 1970. Oil on canvas, 97 x 73". Collection the artist

Mel Casas. *Humanscape 68 (Kitchen Spanish)*. 1973. Oil on canvas, 97 x 73". Collection the artist

Gaspar Enríquez. *Tirando Rollo (I Love You)* (triptych). 1999. Acrylic on paper, 81 x 58" overall. Collection Cheech and Patti Marin

Diane Gamboa. *Green Hair*. 1989. Oil on paper, 18 x 25". Collection Cheech and Patti Marin

Diane Gamboa. *She Never Says Hello*. 1986. Mixed media on paper, 24 x 36". Collection Cheech and Patti Marin

Diane Gamboa. *Tame a Wild Beast*. 1991. Oil on canvas, 54 x 54". Collection the artist

Diane Gamboa. *Time in Question*. 1991. Oil on canvas, 54 x 54". Collection the artist

Margaret García. *Eziquiel's Party*. 2000. Oil on canvas, 54¼ x 44¾". Collection Cheech and Patti Marin

Margaret García. *Janine at 39, Mother of Twins*. 2000. Oil on canvas, 47½ x 35½". Collection Cheech and Patti Marin

Margaret García. *Un Nuevo Mestizaje Series* (The New Mix). (16 works). 1987–2001. Oil on canvas, oil on wood, 96 x 96" overall. Collection the artist

Rupert García. *Homenaje A Tania y The Soviet Defeat* (Homage to Tania and the Soviet Defeat) (diptych). 1987. Oil on linen, 101 x 69" overall. Collection the artist

Rupert García. *La Virgen de Guadalupe & Other Baggage*. 1996. Pastel on three sheets of museum board, 31½ x 40" each. Collection the artist. Courtesy the artist and the Rena Bransten Gallery, San Francisco, and Galerie Claude Samuel, Paris

Carmen Lomas Garza. *Earache Treatment Closeup*. 2001. Oil and alkyd on canvas, 14 x 18". Collection the artist

Carmen Lomas Garza. *Heaven and Hell II*. 1991. Oil and alkyd on canvas, 48 x 36". Collection the artist © 1991 Carmen Lomas Garza

Carmen Lomas Garza. *Quinceañera* (The Fifteenth Birthday). 2001. Oil and alkyd on linen on wood, 48 x 36". Collection the artist

Carmen Lomas Garza. *Una Tarde/One Summer Afternoon*. 1993. Alkyd on canvas, 32 x 24". Collection the artist © 1993 Carmen Lomas Garza

Gronk. *Getting the Fuck Out of the Way*. 1987. Oil on canvas, 48 x 48". Collection Cheech and Patti Marin

Gronk. *Hot Lips*. 1989. Acrylic on canvas, 67 x 70". Collection William Link and Margery Nelson

Gronk. *Josephine Bonaparte Protecting the Rear Guard*. 1987. Acrylic on canvas, 60 x 72". Collection Joanna Giallelis

Gronk. *La Tormenta Returns* (triptych). 1998. Acrylic and oil on wood, 144 x 96" overall. Collection Cheech and Patti Marin

Gronk. *Pérdida (ACCENT ON THE e)*. (Lost). 2000. Mixed media on handmade paper mounted on wood, 118 x 60". Collection Cheech and Patti Marin

Raul Guerrero. *Club Coco Tijuana*. 1990. Gouache and chalk pastel on Arches paper, 22¼ x 14¼". Collection Cheech and Patti Marin

Raul Guerrero. *Molino Rojo* (Moulin Rouge). 1989. Arches paper, pastel, and gouache, 15 x 22". Collection Cheech and Patti Marin

Wayne Alaniz Healy. *Beautiful Downtown Boyle Heights*. 1993. Acrylic on canvas, 94 x 69¾". Collection Cheech and Patti Marin

Wayne Alaniz Healy. *Pre-Game Warmup*. 2001. Acrylic on canvas, 120 x 96". Collection Cheech and Patti Marin

Wayne Alaniz Healy. *Una Tarde en Meoqui* (An Afternoon in Meoqui). 1991. Acrylic on canvas, 53½ x 53¾". Collection Cheech and Patti Marin

Adan Hernández. *Drive-by Asesino* (diptych). 1992. Oil on canvas, 55 x 60¼" overall. Collection Cheech and Patti Marin

Adan Hernández. *La Bomba* (diptych). 1992. Oil on canvas, 57 x 59" overall. Collection Cheech and Patti Marin

Adan Hernández. *La Estrella que Cae* (The Falling Star). 1991. Oil on canvas, 48 x 58". Collection Cheech and Patti Marin

Adan Hernández. *Sin Titulo II* (Untitled). 1988. Oil on canvas, 60 x 46". Collection Lisa Ortiz

Ester Hernández. *Astrid Hadad in San Francisco*. 1994. Pastel on paper, 30 x 44". Collection Cheech and Patti Marin

Leo Limón. *Ay! Dream of Chico's Corazon* (Dream of Chico's Heart). 1992. Acrylic on canvas, 10½ x 13½". Collection Cheech and Patti Marin

Leo Limón. *Cup of Tochtli*. 1997. Pastel on paper, 20½ x 19½". Collection Cheech and Patti Marin

Leo Limón. *Frida and Palomas*. 2001. Acrylic on canvas, 24 x 36". Collection Cheech and Patti Marin

Leo Limón. *Los Muertos*. 1998. Acrylic on canvas, 56 x 40". Collection Cheech and Patti Marin

Leo Limón. *Mas Juegos* (More Games). 2000. Acrylic on canvas, 48 x 69³/₄". Collection Cheech and Patti Marin

Leo Limón. *Un Poquito Sol*. 1991. Acrylic on canvas, 47¹/₄ x 59". Collection Cheech and Patti Marin

Leo Limón. *Wild Ride*. 1996. Pastel on paper, 25¹/₄ x 19". Collection Cheech and Patti Marin

Gilbert Lujan. *Blue Dog*. 1990. Pastel on paper, 44 x 30". Collection Cheech and Patti Marin

Gilbert Lujan. *Boy and Dog*. 1990. Pastel on paper, 44 x 30". Collection Cheech and Patti Marin

César Martínez. *Bato con Cruz* (Dude with Cross). 1993. Watercolor on paper, 17³/₄ x 21³/₄". Collection Cheech and Patti Marin

César Martínez. *Bato con Sunglasses*. 2000. Oil on canvas, 44 x 54". Collection Cheech and Patti Marin

César Martínez. *Camisa de Cuadros* (Shirt with Squares). 1990. Watercolor on paper, 14 x 18". Collection Cheech and Patti Marin

César Martínez. *El Guero* (The Light-Skinned One). 1987. Oil on canvas, 44 x 54". Collection Cheech and Patti Marin

César Martínez. *Hombre que le Gustan las Mujeres* (The Man Who Loves Women). 2000. Oil on canvas, 44 x 54". Collection Cheech and Patti Marin

César Martínez. *Sylvia With Chago's Letter Jacket*. 2000. Oil on canvas, 44 x 54". Collection Cheech and Patti Marin

Frank Romero. *The Arrest of the Paleteros* (diptych). 1996. Oil on canvas, 144 x 96" overall. Collection Cheech and Patti Marin

Frank Romero. *Back Seat Dodge, Homage to Keinholtz*. 1991. Oil on canvas, 47¹/₂ x 35¹/₂". Collection Cheech and Patti Marin

Frank Romero. *Cruising #1*. 1988. Monoprint, 29¹/₂ x 22". Collection Cheech and Patti Marin

Frank Romero. *Downtown Streetscape*. 2000. Oil on canvas, 52 x 40". Collection Cheech and Patti Marin

Frank Romero. *¡Méjico, Mexico!* (4 panels). 1984. Mixed media, 288 x 120" overall. Collection Cheech and Patti Marin

Frank Romero. *Johanna*. 1991. Pastel on paper, 40 x 22". Collection Cheech and Patti Marin

Frank Romero. *La Llorona* (The Weeping Women). 1985. Oil on canvas, 50 x 72". Collection Cheech and Patti Marin

Frank Romero. *Pink Landscape*. 1984. Oil on canvas, 60¹/₄ x 36". Collection Cheech and Patti Marin

Alex Rubio. *La Lechuza* (The Owl Woman). 2001. Oil on wood panel, 48 x 84". Collection Cheech and Patti Marin

Marta Sánchez. *La Danza* (The Dance). 1994. Oil enamel on metal, 35¹/₂ x 59¹/₂". Collection Cheech and Patti Marin

Eloy Torrez. *Diane Gamboa*. 2000. Oil on canvas, 18¹/₄ x 33". Collection Cheech and Patti Marin

Eloy Torrez. *Herbert Siguenza*. 2000. Oil on canvas, 15 x 19". Collection Cheech and Patti Marin

Eloy Torrez. *The Red Floor*. 1990. Acrylic on paper, 35 x 55". Collection Cheech and Patti Marin

Jesse Treviño. *Guadalupe y Calaveras*. 1976. Acrylic on canvas, 66 x 48". Collection Terry Vasquez

Jesse Treviño. *Los Piscadores*. 1985. Acrylic on canvas, 82 x 48". Collection Judge Juan F. Vasquez

John Valadez. *Beto's Vacation (Water, Land, Fire)* (triptych). 1985. Pastel on paper, 50 x 68", 50 x 72", 50 x 68". Collection Dennis Hopper

John Valadez. *Car Show*. 2001. Oil on canvas, 96¼ x 76". Collection Dennis Hopper

John Valadez. *Getting Them Out of the Car*. 1984. Pastel on paper, 100 x 37½". Collection Cheech and Patti Marin

John Valadez. *Pool Party*. 1986. Oil on canvas, 107 x 69". Collection Cheech and Patti Marin

John Valadez. *Revelations*. 1991. Pastel on paper, 50½ x 61". Collection Cheech and Patti Marin

John Valadez. *Tony and Edie*. 1986. Pastel on paper, 50 x 38". Collection Robert Berman

Patssi Valdez. *Autumn*. 2000. Acrylic on canvas, 52 x 66". Collection Cheech and Patti Marin

Patssi Valdez. *Broken Dreams*. 1988. Acrylic on canvas, 36¼ x 36½". Collection Cheech and Patti Marin

Patssi Valdez. *The Dream*. 2000. Acrylic on canvas, 96 x 72". Collection the artist

Patssi Valdez. *Happy Birthday*. 2000. Acrylic on canvas, 72 x 48". Collection Cheech and Patti Marin

Patssi Valdez. *Little Girl With Yellow Dress*. 1995. Acrylic on canvas, 36 x 36". Collection Cheech and Patti Marin

Patssi Valdez. *Rainy Night*. 2000. Acrylic on canvas, 53 x 66". Collection Cheech and Patti Marin

Patssi Valdez. *Room on the Verge*. 1993. Acrylic on canvas, 72 x 48". Collection Cheech and Patti Marin

Patssi Valdez. *Saturday*. 1997. Acrylic on canvas, 24 x 36". Collection Cheech and Patti Marin

Vincent Valdez. *Kill the Pachuco Bastard!*. 2001. Oil on canvas, 72 x 48". Collection Cheech and Patti Marin

George Yepes. *Axis Bold as Love*. 2001. Acrylic on canvas, 60 x 96". Collection Cheech and Patti Marin

George Yepes. *La Magdalena*. 2000. Oil on canvas, 41 x 80". Collection Cheech and Patti Marin

George Yepes. *La Pistola y el Corazon* (The Pistol and the Heart). 1989. Serigraph, 34 x 42". Collection Cheech and Patti Marin

George Yepes. *La Pistola y el Corazon* (The Pistol and the Heart). 2000. Oil on canvas, 60 x 81½". Collection Cheech and Patti Marin

CREDITS

The author, publisher, and exhibition organizer fully acknowledge the photographers, museums, and individuals for supplying the necessary materials and permission to reproduce their work. Unless otherwise noted below, all works were photographed by Peggy Tenison or John White.

M. Lee Fatherree: © 1993 Carmen Lomas Garza, *Una Tarde* and © 1991 Carmen Lomas Garza, *Heaven and Hell II*

Los Angeles County Museum of Art: Carlos Almaraz, *Early Hawaiians*

David Shindo: Gaspar Enríquez, *Tirando Rollo*

Tom Wilson: Mel Casas, *Humanscape 62, Humanscape 63,* and *Humanscape 68*

ACKNOWLEDGMENTS

There are a number of people and institutions I'd like to thank, but it seems fitting that I begin with Stacy King, President and CEO of Clear Channel Entertainment, Inc., for her faith in this project and for being so instrumental and imaginative in developing the exhibition "Chicano Visions." Also at Clear Channel, my thanks to Anne Powers, Mark Greenberg, Dennis Bartz, Cathryn LeVrier, Michele Stevens, and Delfina Sanchez. A special nod of appreciation goes to Peter Radetsky, working in conjunction with Clear Channel, for organizing the Chicano experience into a coherent exhibition.

Target Stores have been great in helping us to get this exhibition off the ground and for being generous in their support. My thanks also go to the Hewlett-Packard Company for helping to fund this exhibition.

Over the years, I have had the pleasure to work with a number of art dealers who opened the world of Chicano art to me, among them: Robert Berman, Daniel Saxon, Sofia Perez, Julie Rico, Craig Krull. Gabriella Trench stands out for having been my eyes, my ears, even my legs in assembling part of my collection.

To the lenders of the exhibition and this book—institutions, patrons, and artists—*muchas gracias.*

Director George Neubert at the San Antonio Museum of Art has been a longtime supporter of Chicano art, and the museum deserves many hosannahs for having been the first to mount this great survey of Chicano artists. At the Museo Americano, I want to thank Henry Muñoz, the director and founding chairman of the Alameda, and his staff.

How could I not thank the distinguished publishing house, Bulfinch Press? Carol Judy Leslie was the person who first championed this project before it passed into the capable and energetic hands of publisher Jill Cohen. Also at Bulfinch, Karyn Gerhard was key in moving the book along its way.

Behind the scenes, and working with me to make this book fantastic, is my editor, Ruth Peltason, of Bespoke Books. Ruth's tireless efforts have guided this book through the course of its long journey. Without her, this book truly would not have been possible. And to the book designer, Ana Rogers, thank you for understanding Chicano art so well.

To my wife, Patti, my love always for her great and different eye.

And thanks, above all, to the artists for creating the work that we celebrate in this book.

Con amor y besos,
Cheech Marin